SAMUELE MAZZA

In the Bag

CHRONICLE BOOKS

SAN FRANCISCO

First published in the United States in 1997 by
Chronicle Books.

Copyright © 1996 by Idea Books, Milano.

Translation copyright © 1997 by Joe McClinton.

Printed in Italy

Edited by Samuele Mazza
Editorial Coordination by Angela Passigli
Photographs by Wahb Mabkhout
Exhibition Services by W.E.A. (World Exhibition
Association)
Cover and text design: Martine Trélaün

ISBN: 0-8118-1798-9

Library of Congress Cataloging-in-Publication
Data available.

Distributed in Canada by Raincoast Books
8680 Cambie Street
Vancouver, B.C. V6P 6M9

10 9 8 7 6 5 4 3 2 1

Chronicle Books
85 Second Street
San Francisco, CA 94105

Web Site: www.chronbooks.com

SPECIAL THANKS TO:

Rose Marie Parravicini
Mariacristina Parravicini
Claudia Barazzutti
Viviana di Blasi
Massimo Grassi
Maurizio De Caro
Sebastien Pruna
Renata Sapey
Judith Clark
Alessandro Re
Sergio D'Agostino
Mariuccia Casadio
Marco Meneguzzo
Antonio Miredi
Riccardo Braccialini
Roberta Gemelli
Maria Luisa Gemelli
Claudio Ferri
Claudio Patti
Lucrezia De Domizio
 Durini
Angela Passigli
Paolo Cotza

Giuseppe di Somma
Francesca Richards
Cristina Morozzi
Letizia Bordignon
Arturo Senserini
Marilli Alessandretti
Johnny Dell'Orto
Alessandro Guerriero
Mauro Muzzolon
Federica Molteni
Erica Calvi
Danila Sabella
Aldo Moretti
Bona Bonarelli
Rosi delle Piane
Giulia Masla
Oriella Vallini
Vogue Pelle
Piero Gemelli
Maurizio Pracella
Massimo Vincenzo
 Consiglio

Contents

Presentation

MAURIZIO DE CARO

There is no imaginable object that could be subjected to more puns and semantic substitutions than the bag. Of all of the feminine accessories, the bag is one of the central objects of desire tied to a function: to hold something that, in fact, is unknown to us.

This exhibition will begin its journey in the temple of Italian architecture: la Triennale in Milan, a place that is associated with the evolution of design research. The theme is particularly stimulating for the designer, whether it's a graphic designer, an architect, a "creative," or a stylist, because, as opposed to other objects, the bag is the most functional.

The most fascinating of all bags is the suitcase, because it suggests to us the greatest of all mysteries, travel. "Into a suitcase I insert a mystery, i.e., the things that I will bring, but I will use these things in a place that I don't know, therefore there is a double system of unknowns." The design choice can be high- or low-tech. But it is in the movies that the bag becomes a metaphor, like the bag of Mary Poppins, which represents the child's universe: the playroom—the Victorian bag that contains the materialization of all of our needs and allows us to pass from chaos to order, from fantasy to reality.

Luis Buñuel filmed Catherine Deneuve strolling on an imaginary planet with an infinite succession of Chanel bags. But it is in a "house of appointments" that she will have a casual encounter with a man who will reveal the contents of a small box, and no one will ever know what it contains. Deneuve disappears and with her disappears the mystery. Typically a feminine object, the bag evolved in the masculine world during the period of the triumph of

unisex, an era which gave birth to that deprecated object that sublimates the very concept of kitsch: the shoulder bag.

In this exhibition I have emphasized the object in itself. Certain objects overpower our imaginations once they are organized into categories. The exhibit shows the development of and the communication that is born from all of the objects present in one singular perceptive moment: a flux! Now that we are at the end of our journey, we see the same bag as at the beginning because, paradoxically, there is no evolution in this journey, only circularity.

8

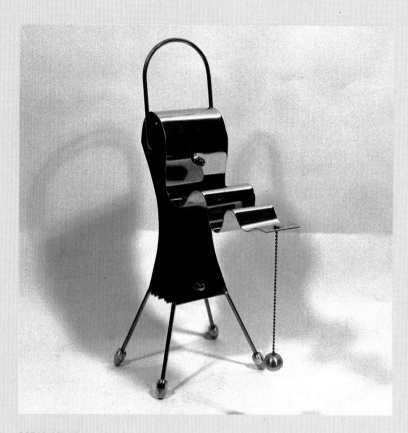

GORAN LELAS,
Borsa meccanica
(Mechanical Purse),
steel,
Zagreb 1996.

Tell Me What Bag You Have and I Will Tell You Who You Are

SAMUELE MAZZA

"In the Bag" does not allude to containers to keep things in. Rather, it is about "places" in which to gather what is "necessary."

Our houses contain hundreds of useful and useless objects (and in any case, doesn't anything we keep have—for whatever obscure reason—an intrinsic use?). Yet any time we leave home, a kind of summing-up becomes imperative, and our last thought is always for the object called a "bag."

There are so many bags, of so many shapes and sizes, yet all have the same use: to hold whatever allows us to perform a temporary migration. A bag is also the only clothing accessory that we do not actually wear. It is like a satellite around our body, retained by straps or strings, or simply held in the hand—and a source of sudden anxiety at the thought of having lost it.

Apropos, some of my "inventor" friends are working on a remote control with a photosensitive cell. It can be attached to a bag and make it "autonomous." The bag will be able to follow us; we will no longer have to labor under its weight or ever fear mislaying it. There will be new traffic jams of bags, or whatever else must follow its owner, to be added to this muddled world of air and car and rail traffic.

Already one finds oneself wondering what the dogs will think of that, as they watch these trailing, robotic companions pulling up alongside and then overtaking them.

We might actually see snatched purses finding their own way home. Even if carefully emptied, they would still be worth recovering: Some purses cost thousands. And purse snatchers would have to change titles and become purse-nappers, forced to chain up these irrepressible, incorrigible objects.

UGO LA PIETRA,

Zaino/Casa
(Rucksack/House),

Watercolor on cotton paper,
Milan 1994.

ZAINO / CASA

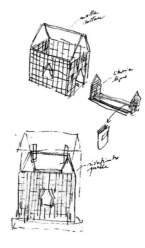

Amid this context of digressions on containers and their contents, the actual thing to wonder should be this: Are some objects symbolically possessed by us, or are we in fact possessed by them? I think the latter alternative is, paradoxically, the more plausible. Especially if you have ever come across a purse on the street. Apart from the delight of the potential windfall involved, there arises a morbid curiosity about whose it is. And certainly we investigate not so much to facilitate its return as from a natural eagerness to get to know a new, alien individual. To discover, through the contents of their bag, what kind of person they are. What kind of keys do they carry? In a brand-name keyholder or not? Driver's license, date books with unknown or important names, even the kind of condoms, tell us something a priori about the owner. It's undeniable: There is always a certain embarrassment at returning or recovering a lost bag. The glances of both parties always carry a certain eloquent shared and secret knowledge: "I know you; your bag told me everything."

I'd like to dedicate this volume to my mother, Sara, who had her own bag snatched in its time, irremediably taking with it some of her most cherished objects, like the jewels from the day she married her adored and only husband.

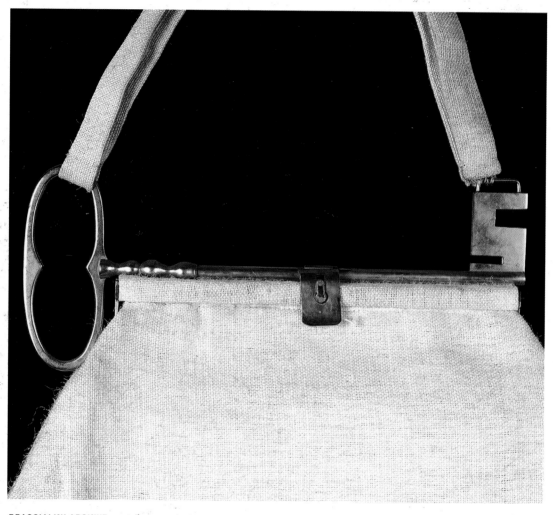

BRACCIALINI ARCHIVE,

Sicura
(Safe),

fabric, metal,
Florence 1960s.

Vintage

B A G S

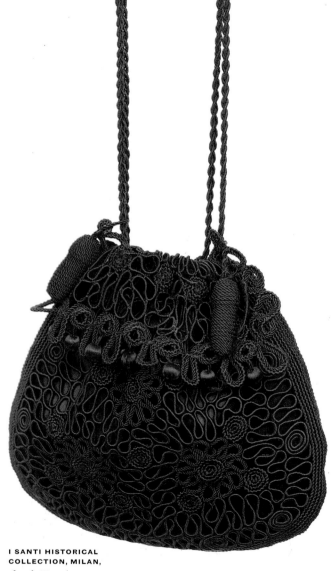

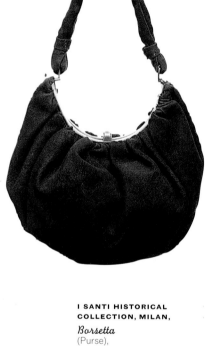

14

**I SANTI HISTORICAL
COLLECTION, MILAN,**

Borsetta
(Purse),

suede.

**I SANTI HISTORICAL
COLLECTION, MILAN,**

Sacchettino da sera
(Purse),

macrame.

'50s

I SANTI HISTORICAL COLLECTION, MILAN,

Borsa
(Purse),

fabric, brown velvet.

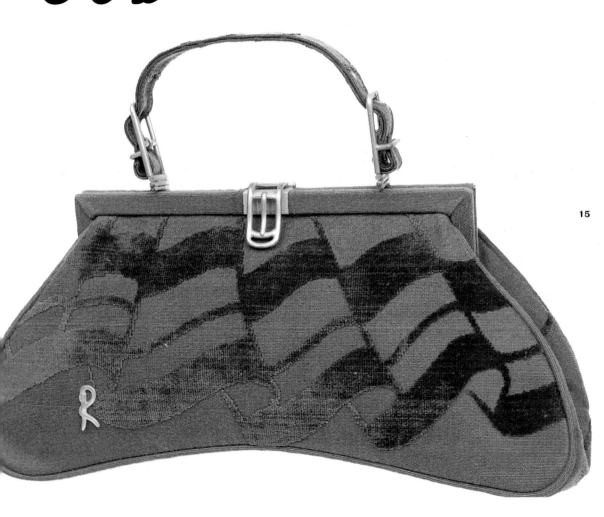

'50s

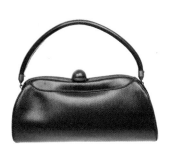

I SANTI HISTORICAL COLLECTION, MILAN,

Borsa, linea bassotto
(Low-line purse),

leather.

I SANTI HISTORICAL COLLECTION, MILAN,

Micro borsa, modello americano
(Micropurse in the American style),

leather.

I SANTI HISTORICAL COLLECTION, MILAN,

Borsa, linea bassotto
(Low-line purse),

leather.

18

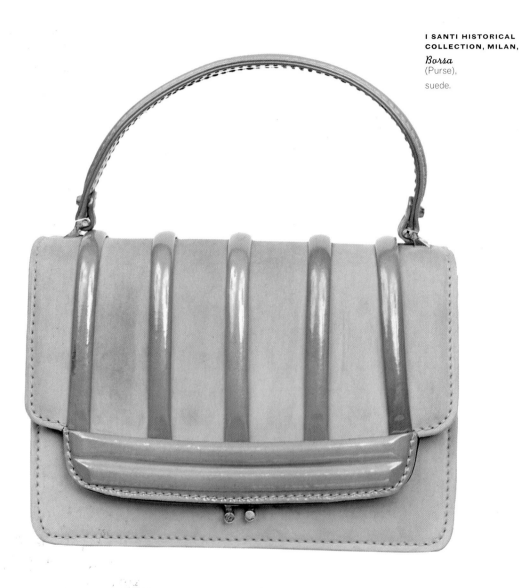

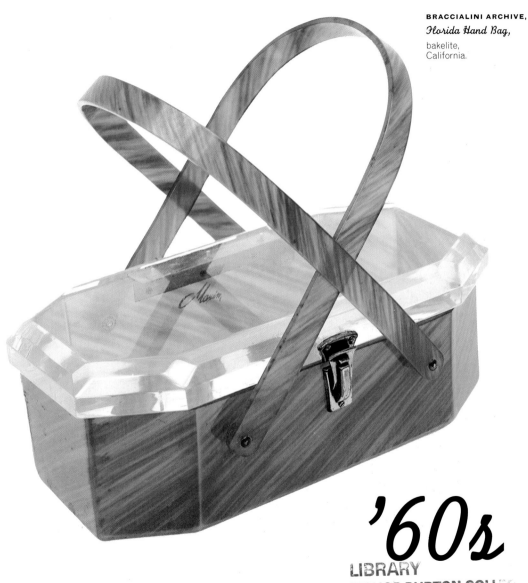

19

'60s

I SANTI HISTORICAL COLLECTION, MILAN,

Borsa
(Purse),

calfskin.

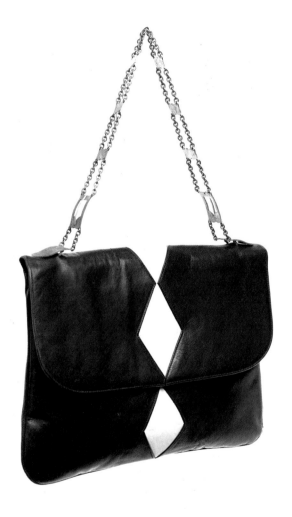

I SANTI HISTORICAL COLLECTION, MILAN,

Busta
(Envelope bag),

leather.

'60s

I SANTI HISTORICAL
COLLECTION, MILAN,
Borsa
(Purse),
velvet.

I SANTI HISTORICAL COLLECTION, MILAN,
Borsello da uomo
(Men's bag),
calfskin.

'70s

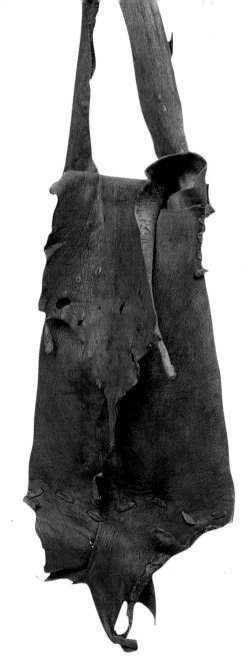

I SANTI HISTORICAL
COLLECTION,
Untitled,
leather.

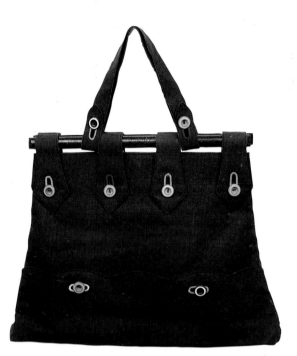

BRACCIALINI ARCHIVE,
Attaccabottone
(Buttonholed),
canvas, plastic.

'80s

Borsa-cono
(Cone purse),
leather.

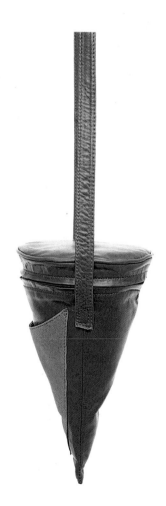

'90s

DANIELA RAVAIOLI FOR RADA,

Borsa
(Purse),

vinyl,
Forli.

MINO BOSSI

Borsa
(Purse),

leather, metal,
Florence.

DESMO,

Borsa
(Purse),

leather,
Florence.

The Bag As Destiny

MARIUCCIA CASADIO

"Her accessories were perfect: even her evening bag, for example, a golden box purse in the shape of a dove with folded wings, designed by Salvador Dalí, one of the most beautiful feminine objects ever seen." (Lietta Tornabuoni, about Irene Brin)

I was a girl in the sixties, tossed hither and thither amid the merits and defects of an economy euphoric from the boom. And in that festive hubbub of deceits and possibilities, the eternal purse seemed to me among the most attractive and indispensable of products. Changeable and promising by its very nature. Congenial and in perfect harmony with my own feminine nature.

Though still in the bud and certainly innocent of any more calculating motivations in this regard, I was especially fond of the more refined aspects of purses: the classic styles and the many, highly personalized ways of carrying them. I watched and mentally selected those at the wrists of certain fascinating women, who transformed the ritual of shopping into a playful, nonchalant piece of performance art, who knew how to make the bag seem as magically light as a silk scarf. And naturally, I also loved the purses owned by my mother, a diligent and impeccable interpreter of bourgeois imagery.

Nor, while I was growing up, did I neglect to memorize the more illustrious purses of Jacqueline Kennedy or Wallis Simpson, Audrey Hepburn, or Brigitte Bardot, from the little eighteen-carat gold boxes for official galas to the basket bags lined with checked cotton, all the rage at Capri and Saint Tropez. Then, already an adolescent, I came to realize that these were almost always "designer originals," or digressions on the same theme: from Chanels with chain handles to the shoulder bags with spring-clip straps or the rigid

bamboo-trimmed models created by Gucci. Or from the creations by Roberta di Camerino, in trompe l'oeil velvet brocade, to the Kelly bags by Hermès, and so much more, to the futuristic designs of Courrèges and Paco Rabanne. I knew for certain that from plastic to metal, from ostrich to tortoise shell, from silk moiré to marabou feathers, there were no limits in this realm. Not in form, and not in substance. And although a habituation to designer works entered my life between the late sixties and the subsequent decade, as I jealously leafed through Vogues featuring Veruschka, Penelope Tree, Donyale Luna, and later Iman, Donna Jordan, and so on, the mythology of box bags, clutch bags, vanity cases, shoulder bags, carry-ons, beach and town bags, picnic baskets, Oriental baskets, evening bags of velvet or crêpe de chine, was perhaps something I was born with, part of the nature of my sex, like a congenital destiny.

For women of my generation, one's choice of a purse was rigorously subordinated to or contrasted with the color and design of one's shoes. Not to mention the role it was to play. From designer originals to all the derivations, imitations, clones, simulations, identical and elaborated copies, the purse lightly accompanied the "coordinated" steps of the women who enchanted me most. And it connoted the character and quality of how they spent their days. I would never have taken a beach bag to go walking in town, or a bag for streetwear to dinner.

As a little girl, I used little purses to carry my favorite toys around in secret. Later, from straw lunch basket to bookbag, my first years at school required me to replace my "street styles" with more drearily functional and standardized containers. Until that moment (and since that interlude as

well) my ideal purse had always been one with a short handle. And although in summer it was of straw or raffia, between winter and spring I made shift with the few alternatives available in my cupboard: A few were of rag-cloth or calf, in those colors and shapes that could be more easily associated with the presumed imagery of childhood, in an era when the market was still very short on ideas and alternatives in specialized product lines.

Others undoubtedly came from my mother's evening collection, perhaps because box bags or clutch purses, small or indeed even microscopic, better matched my childish proportions.

I recall the fundamental role purses played in the training of my contemporaries. In those years, knowing how to carry a bag was equivalent to having taken classical dance lessons. And while the dentist set to work redesigning the mouths of childhood with those murderous iron braces, careless of the pain he inflicted and convinced he was causing not the slightest identity crisis, our purses inculcated us girls with a naturalness of bearing and of gesture. The purse reinforced the acceptance of a destiny that was not merely genetic but also, and above all, social, composed of differences, limitations, strategic expedients under the shelter of codified behavior. It also reinforced the bourgeois predilection for sexual discriminations.

Yet the purse is by no means, or at least not only, synonymous with banal, highly predictable female frailties. At bottom, any impeccable and constrictive type of uniform, designed for defense and for offense, is created by male ingenuity and by a male psychology. Only in appearance does it

28

restrain the potential for complete freedom of movement and gesture. In fact, it concentrates and enhances the physical authority and the identity of the wearer. Hence, if we consider feminine style in terms of power; if we translate the signs of its uniforms into qualities of reflections from a code that was originally inflected from the masculine; if we apply a logical process of equivalents, then the suit, purse, and high-heeled shoe become a uniform tailor-made for the feminine anatomy and feminine characteristics, intended to arm a woman with fascination. But also, to increase her potential for power, for success (and sometimes for overwhelming victory) in the dialogue-battle with the opposite sex. Consequently, and in a role not the least bit marginal, "ladies'" accessories carry a high proportion of eroticism, attracting one's male interlocutor, intriguing him and arousing his curiosity, very quickly transmuting themselves into weapons of control. Weapons for attraction or rejection.

Crossing one's legs becomes metaphorically insidious when the foot, shod in a low-cut, pointed shoe, culmination point for the erotic gaze gliding from knee to heel, begins to undulate forward and back. It is a kick, perfectly aimed and knowingly deferred, always ready to be loosed like a lance or an arrow, as soon as anyone we are dealing with forgets the danger involved and attempts to approach beyond the limits of safety. Similarly, the purse generated a codifiable series of behaviors, plainly feminine, intended to erect a regular iron curtain. Or if you will, a genuine zone of refuge, when communication began stumbling into zones of ambiguity or deceit, when the tone became too heavy, pedestrian, vulgar and/or otherwise intolerable.

Many envelope bags from the thirties and forties had a little mirror hidden in the front flap. When you opened the purse you were immediately in contact with your own image, so you could evaluate your appearance by imperceptible rotations of your glance. And also, more important, you could observe comings and goings behind your back—detect and forestall the adversary. And if necessary, work out in advance your strategy to avoid him, to catch him in flagrante, to simulate states of mind suitable to press home any plan of attack you wished.

It is perhaps not by chance, either, that radically innovative figures in fashion over the span of more than sixty years, from Coco Chanel to Vivienne Westwood, have never neglected to pronounce their stylistic rulings on the evolution of the purse. Loved or hated, chosen or rejected, plainly in evidence or well concealed, the purse accompanied Marilyn Monroe and Simone Signoret, Greta Garbo and Marlene Dietrich, Simone de Beauvoir and Marguerite Duras, Diana Vreeland and Patricia Highsmith. And thanks to their charisma, as well, the "lady with a purse" has acquired full standing in the list of narrative motifs linked to encounters, whether chance or not, in the literature of the novel and film. Beginning with the reticule, a little satin bag that could be tied to the wrist for parties, used from the nineteenth century to the twenties, and going on to the most varied day models, small and not so small, in calf, chamois, or canvas, with or without handles, in a single color, two-toned, with embroidery or decorative appliqués.

From Alfred Hitchcock to Brian De Palma, but also from Vincent Minelli to Luis Buñuel, or Martin Scorsese to Quentin Tarantino, the cinema has immortalized many ways of dropping a purse by intent, always near

somebody whose acquaintance one wants to make. Or of pretending to forget it in a taxi when, having been driven home, one wants for better or for worse to be run after as far as the house door, and sometimes beyond.

Or even, if the case applies, to transform an occasional companion into a regular visitor. Then there is a codified range of ways to hide one's eyes in a purse: the convulsive search for something, often unexplained or unidentified. Or there is that way—spuriously accidental—of dropping something on the ground. A highly revelatory sign, significant in itself: ambiguous, unsettling, depraved, a source of unquenchable curiosity. Whether pistol or glove, torn-up photograph or silk stocking, knife or perfume bottle, medicines or drugs.

In sum, the purse is a perfect unknown, an unrecognized intriguer. It is an inexhaustible fount of mysteries and metaphors. It is the modern transcription of the classical Pandora's box: a place for irrepressible curiosity, for secrets never unveiled and insidious penalties. And if in their depths these secrets also involve feminine psychology and sensibilities, it is also true that they offer excellent opportunities for industry, that unstoppable divulger of ideas and revealer of an interminable corollary of "accessory" products. Billfolds of every shape and size, little mirrors, brushes, combs, makeup cases or photo wallets, appointment books or checkbooks or credit-card holders, tampons and condoms in little packets, and so on—these all seem to reinforce a functional identity and irreplaceable role as a "neutral" container. But the reality is something else again: The purse is a weapon of seduction well before and beyond its qualities of capacity, strength, and accessory convenience. When we recall that for better or worse, everything a purse might foreseeably contain is also displayed in shop windows,

promoted with brands and advertising images, then come what may, our container should always seem something to be banally taken for granted. Yet given the opportunity to inventory the contents of a purse that does not belong to us, the final impulse would always be to turn it right out and start in. To wring out some further mystery, whatever it might be. To disbelieve appearances, and seek something else.

In fact, nothing is more disappointing than a metaphorical container once the identity of its contents is unveiled. No use restraining our hand, which no matter what, continues to seek, to slip into the darkness of the internal pockets and folds, while the complicit eye peers and squints into the impenetrable dark of a bottomless "inside."

Can anyone ever have resisted Mary Poppins's bag? Is there anyone who has not felt a catharsis in that magical ability to pull out lamps and hat racks, framed paintings and three-legged tables? Yet even in this idyllic instance, excited as we are and identifying with the curiosity of the children who want to explore it to the bottom, we are still not disappointed at their lack of success. Indeed, Mary Poppins's purse also proves to be unbelievably empty, deep and dark as the abyss, elegantly inscrutable. And our own ideal suitcase should be so, too.

Perhaps no one has ever seemed more vulgar to us than someone who exclaims, "How pretty!" and then opens our purse and tries to look inside. The feelings this inevitably provokes have much in common with any other invasion of our privacy. They violate the confines of intimacy, and inevitably reproduce the unpleasant sensation of a stranger in the house, something

very close to psychological violence and morbid curiosity.

A purse as bait, as a repertory of inexhaustible intentions of secrecy, reserve, mysterious attitudes. A purse as an object to be looked at and as the symbolic carrier of contents. From Marcel Duchamp's valise to Mario Merz's wicker basket; or again, in the innumerable variations on the theme signed by Claes Oldenburg, Nicola De Maria, or Georg Herold, twentieth-century art has used the varied shapes of purses, rucksacks, and suitcases to remind us of the secret, metaphorical sense of what might be contained within. Yet also to emphasize how, and to what extent, the external qualities of anything may prompt us to speculate about the beauty of what must be behind, within, beyond what is visible.

That interplay continues in the pages of this book.

It is hard not to have something to say, in the form of a 3-D dream or nightmare, about what seems to be the design of an animated object. Intelligent. Inexhaustibly desirable. And unpredictably never the same, even in this context, the purse as an object has become a portrait of the artist, an aesthetic declaration, a receptacle for surprises, the palpable documentation of the infinite oscillations of taste. Beyond fashion, beyond sex, in compliance with the most varied and autobiographical ideals of style.

The many possibilities collected and pointed out here have a double prerogative. If, on the one hand, they review and interrelate ideas of style with those of art and design, on the other hand they never entirely deny the traditional memory of the object—so that they may then transgress it. Play with it. Turn its connotations inside out.

**RUNWAY SHOTS FROM
FASHION SHOWS BY
MUGLER, VERSACE,
CHANEL, WESTWOOD.**

Photos: Roberto Tecchio.

Fashion
PHILOSOPHY

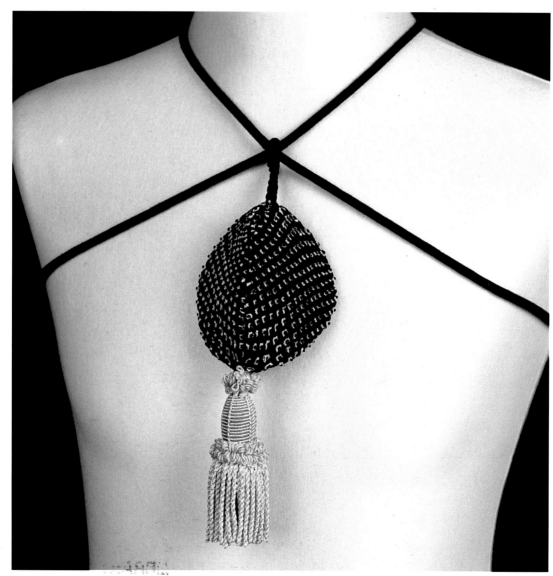

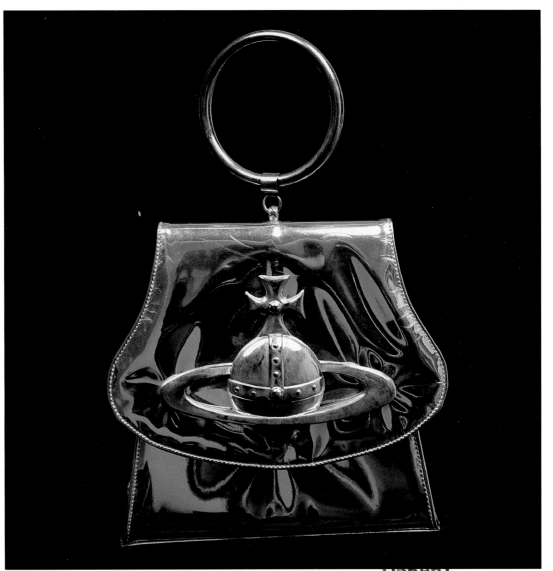

VIVIENNE WESTWOOD,

Borsa
(Purse),

silver plastic,
London 1995.

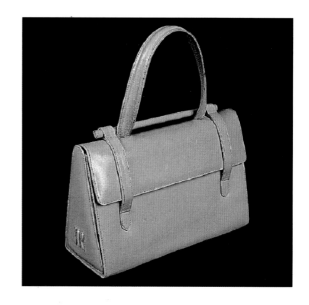

38

SERGIO ROSSI,

Borsa
(Purse),

fabric,
Milan 1996.

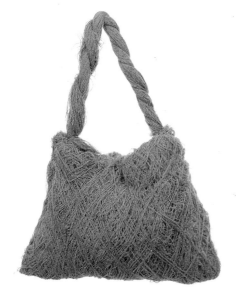

MANUELA SCISCI,

Pazienza
(Patience),

wool,
Milan 1996.

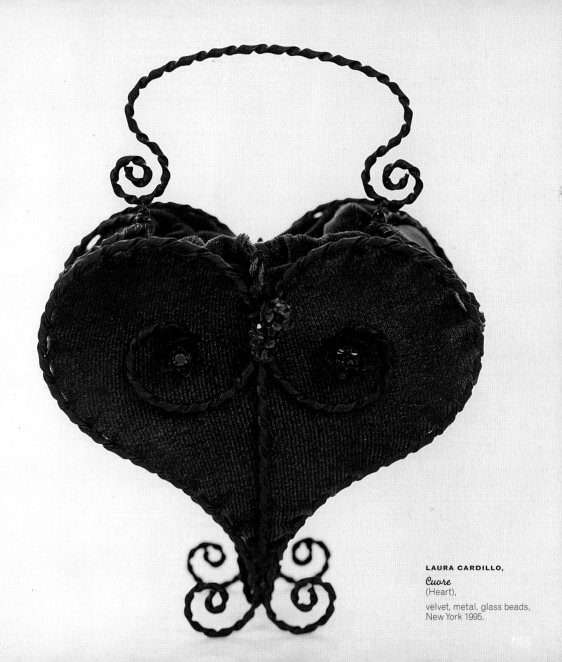

LAURA CARDILLO,
Cuore
(Heart),
velvet, metal, glass beads,
New York 1995.

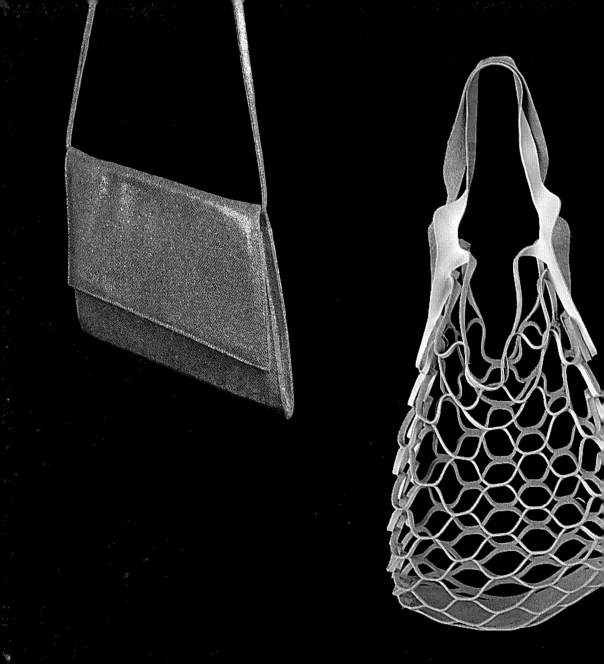

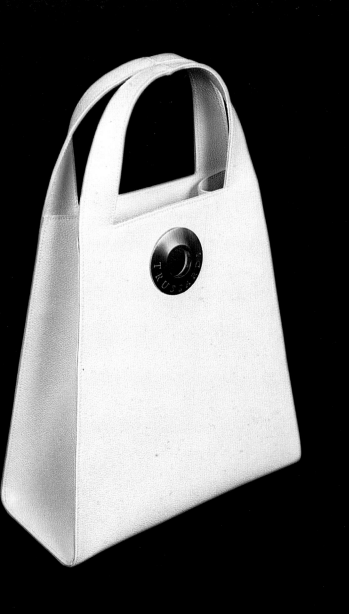

DANIGI FOR KATHARINE HAMNETT,

Borsa
(Bag),

silver leather,
Pianoro (Bo) 1995.

FIORUCCI,

Origamo

leather,
Milan 1996.

NICOLA TRUSSARDI,

Borsa
(Purse),

leather,
Milan 1995.

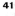

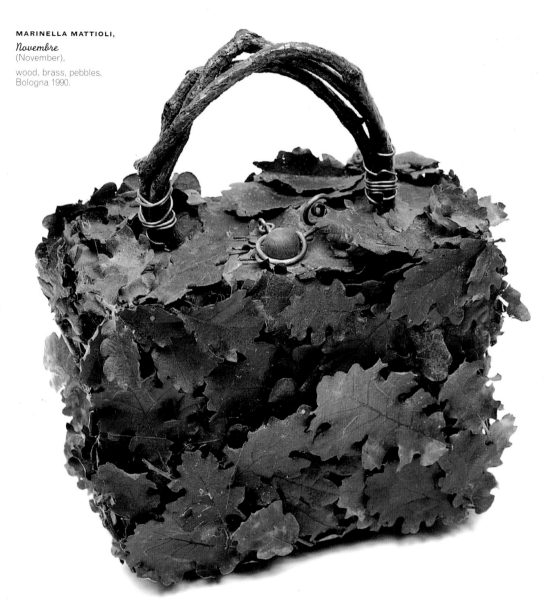

MARINELLA MATTIOLI,
Novembre
(November),

wood, brass, pebbles.
Bologna 1990.

42

ALNOOR MITHA DE BHARAT
FOR GAZELLE D'AMOOR,
The Springtime,
astroturf,
Paris 1995.

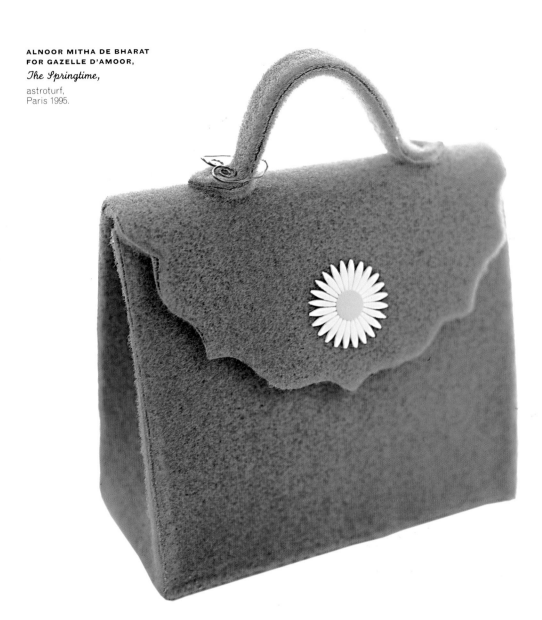

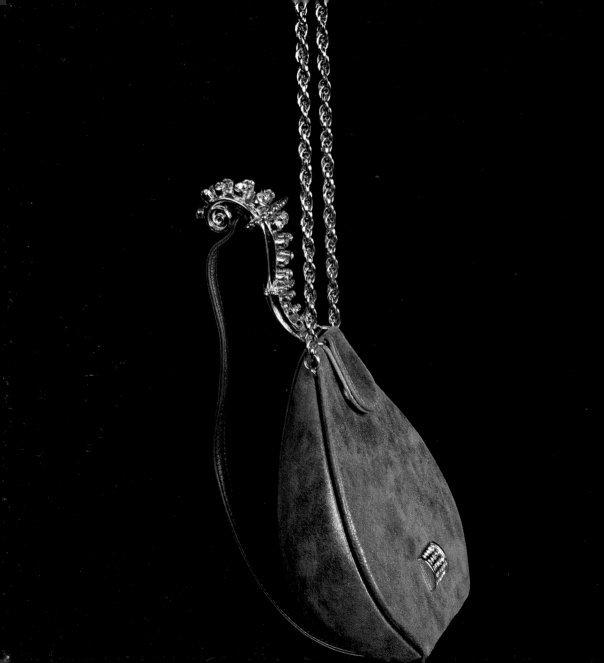

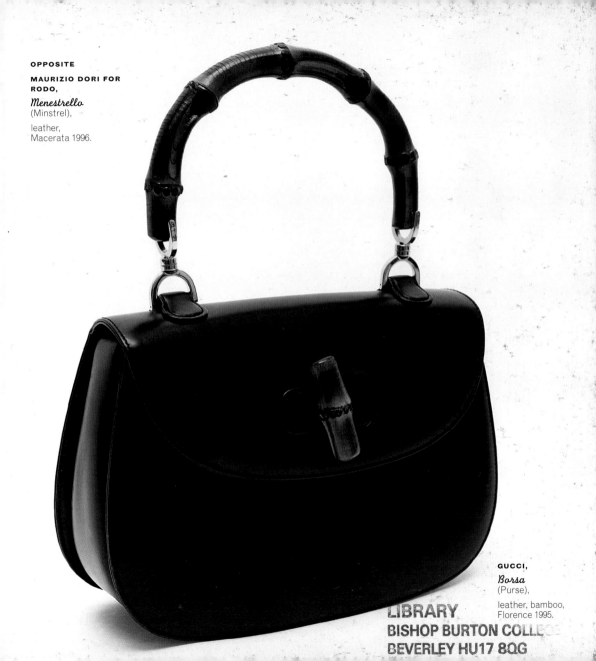

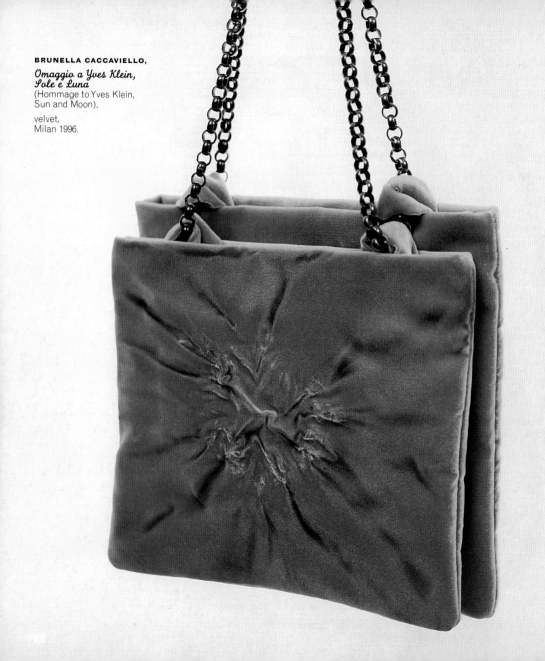

BRUNELLA CACCAVIELLO,

Omaggio a Yves Klein,
Sole e Luna
(Hommage to Yves Klein,
Sun and Moon),

velvet,
Milan 1996.

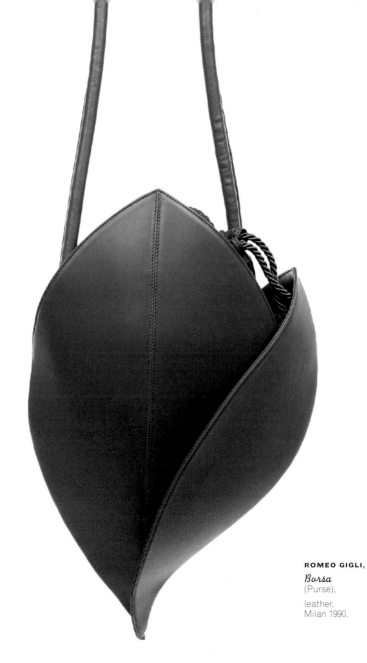

ROMEO GIGLI,

Borsa
(Purse),

leather,
Milan 1990.

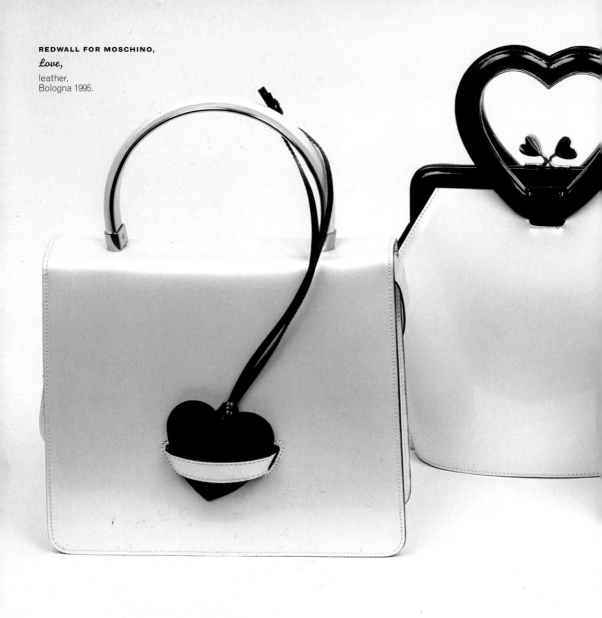

REDWALL FOR MOSCHINO,
Love,
leather,
Bologna 1995.

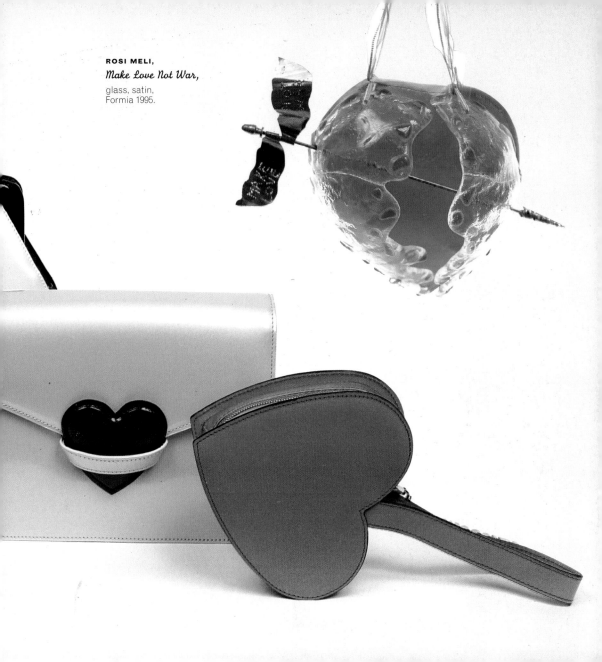

ROSI MELI,

Make Love Not War,

glass, satin,
Formia 1995.

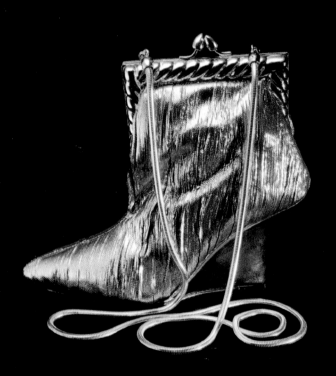

ROBERTA DI CAMERINO,
Bagonghi

leather,
Collezione Colombo,
Milan, 1960.

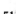

OPPOSITE

MAURIZIO DORI FOR RODO,
Ambivalente
(Ambivalent),

leather, fabric, metals,
Florence 1993.

CLAUDIO D'AVANZO,
Colazione de Tiffany
(Breakfast at Tiffany's),

leather, fabric,
Rome 1995.

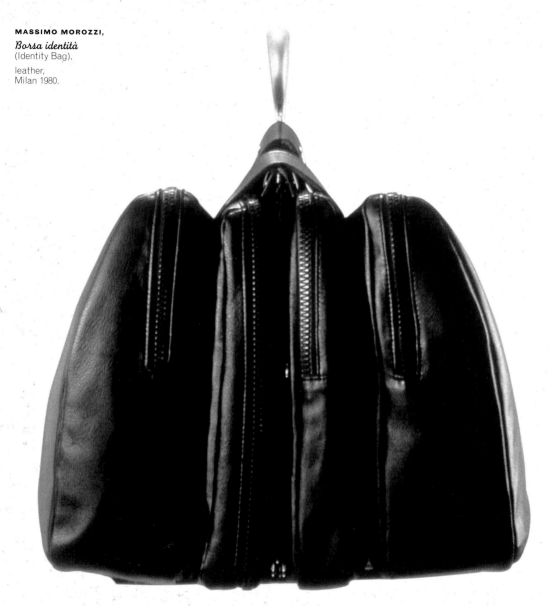

MASSIMO MOROZZI,
Borsa identità
(Identity Bag),
leather,
Milan 1980.

Industrial

D E S I G N

The Bag Is Life

CRISTINA MOROZZI

In the short film *Emile Muller* by debutante director Yvon Marciano, the protagonist was a bag. Or rather, the bag was the element that permitted an aspiring actress in search of a part to unveil her personality. The audition consisted of the actress telling a story by emptying the contents from her bag. Her role was to mime a sort of psychoanalysis session where the bag represents the analyst who quietly exposes the personality of the patient. The aspiring actress who got the part, surpassing many other competitors, outwitted the others by weaving into her story the contents of a bag that she found hanging by the entrance. The moral of this agile little story is that "the bag is life." Every bag is a life. For that reason it is more than a design, it is an architectural blueprint. The bag is not an object but a construction, destined, like the house, to accommodate a life. The difference is only a question of scale: the house accommodates life in its entirety; the bag contains only episodic traces—signs that refer to a way of life, habits, passions and inclinations, like the furniture in a residential interior.

The Bedouin in continual migration constructs his improvised house by unrolling a precious carpet. That carpet represents the domesticity that will follow him to every place. The bag, like the carpet, is a sort of mobile house which accompanies us symbolically: almost a shell from which we can hardly separate ourselves like a tortoise or a snail. Therefore it can be very precious. Precious more than every other accessory because it represents being "not in one place," as Martin Heidegger says about living, but in many places. Because it takes us back to the nomadic condition, first and primeval; because it is the symbol of that existential freedom that allows us to be at home in any place, provided that, naturally,

one has the suitable bag. To design a bag means therefore to construct a house for the traces of life: those that accompany us when we transform from residents to migrants.

To look at bags like a repertoire of residential architecture solicits incredible analogies. There is the trunk, which alludes to the protective house; the bag made of bark or leaves, which refers to a naturalist's house; the transparent bag, which reminds us of the glass architecture of Paul Scheerbart; the hypertechnological bag, which refers to industrial constructions; the little knapsack, which recalls the snail that slowly and inexorably moves with its house on its back. It is helpful, therefore, to approach the design of bags with a manual of architectural styles present, because those are the parameters which should be used for aesthetic judgment.

When faced with a bag, whatever its style may be—of fabric, straw, plastic or fine leather, old or worn—one should consider it with reverence, as if in the presence of an architectural masterpiece, because like buildings, bags also speak of the stories of life.

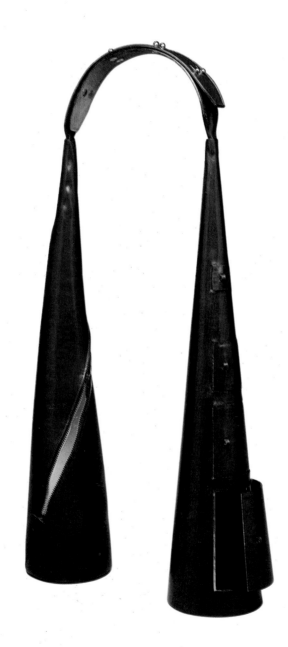

56

RON ARAD,
Les Deux Magots,
leather,
Paris 1980.

57

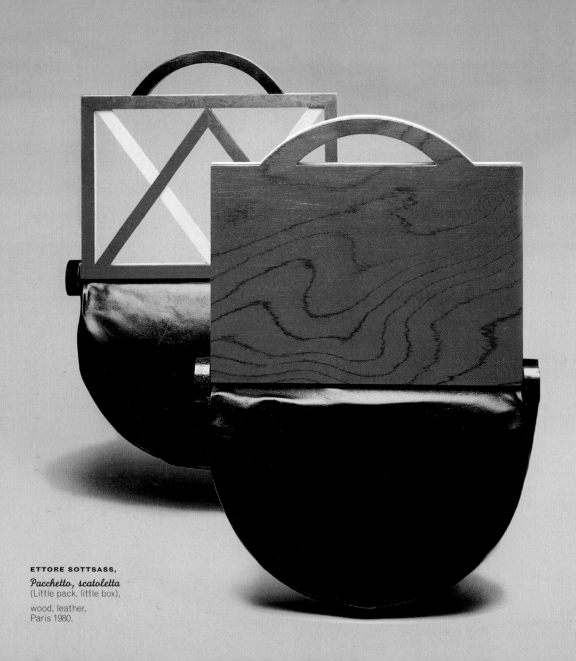

ETTORE SOTTSASS,

Pacchetto, scatoletta
(Little pack, little box),

wood, leather,
Paris 1980.

LAPO BINAZZI,
Borsa multirifiuti
(Trash collector),

wood, leather,
Paris 1980.

SAMUELE MAZZA,

Contenuti e contenitori
(Containers and the things
contained),

plastic,
Florence 1988.

FORTUNA VALENTINO,
Flipper,
leather,
Milan 1995.

GILSON MARTIN,
Ponte
(Bridge),
leather, aluminum,
Rio de Janeiro 1995.

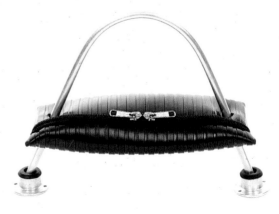

GIUGIARO,
Nazca C2,
leather,
Milan 1995

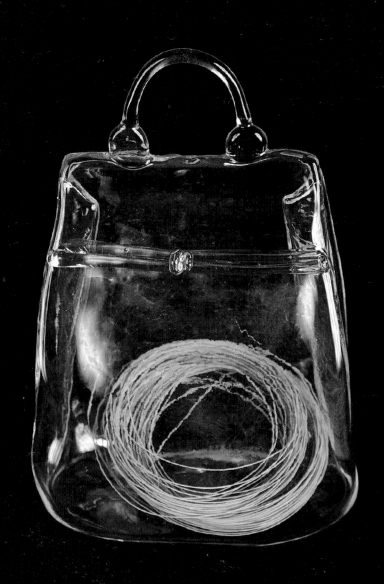

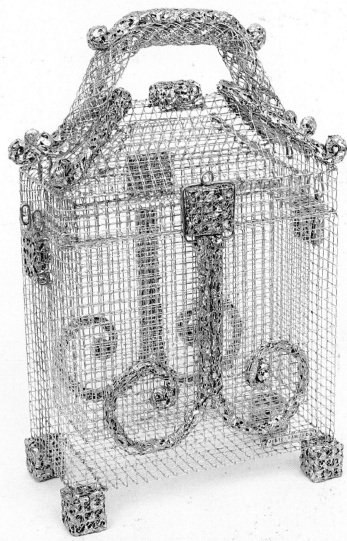

JULIO RAMUNDO,
Cofanetto Pirata
(Pirate Chest),

wire fencing,
Mar del Plata 1996.

GIUSEPPE ARCOFORA,

Thermos,

aluminum, leather, bolts,
Florence 1995.

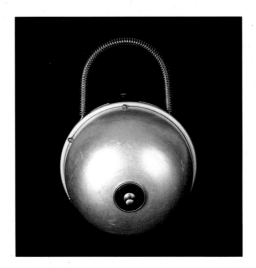

OPPOSITE

GIUSEPPE ARCOFORA,

Vichingo
(Viking),

aluminum,
Florence 1995.

64

ALBERTO FELICETTI,

Cyber Bag,

video cassette,
Milan 1996.

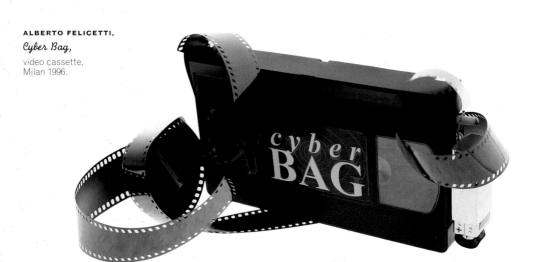

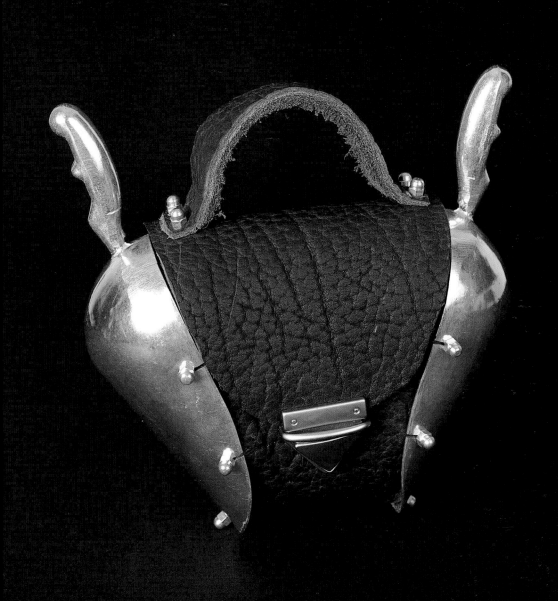

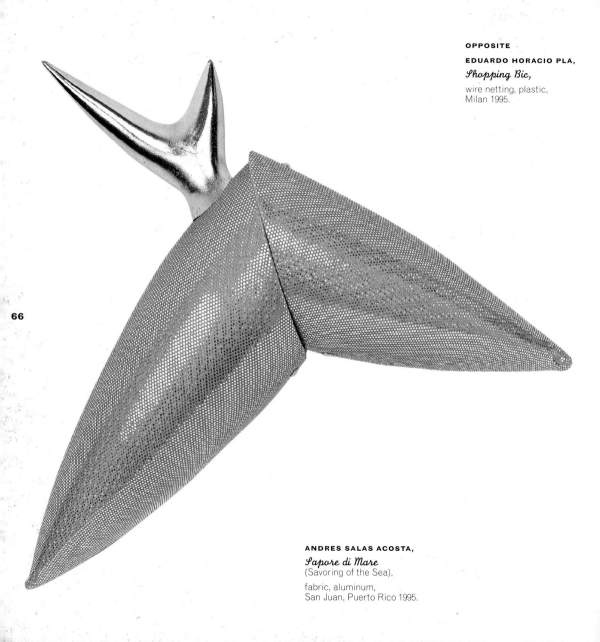

OPPOSITE

EDUARDO HORACIO PLA,

Shopping Bic,

wire netting, plastic,
Milan 1995.

ANDRES SALAS ACOSTA,

Sapore di Mare
(Savoring of the Sea),

fabric, aluminum,
San Juan, Puerto Rico 1995.

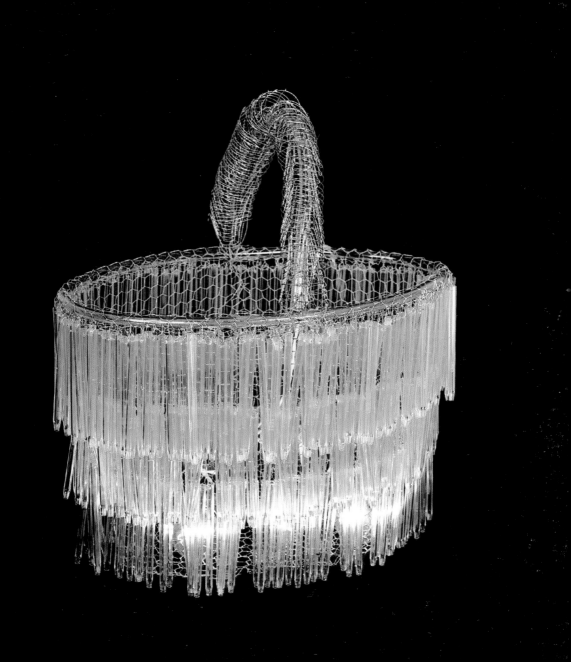

PAOLO FRATINI,

Incontenente
(No Use Holding),

wood,
Florence 1995.

MARTINE BEDINE FOR SINE CARUANA,

Borsa
(Purse),

calf,
Milan 1984.

FRIED ROSENSTOCK,
Luftlente, beihänger,

polycarbonate,
Florence 1995.

SILVA BRUSCHINI,

Narcisa
(Narcissette),

leather, mirrors,
Rome 1996.

FABIO MARIA ALECCI,

Sale sulla coda
(Salt on Its Tail),

P.V.C.,
Rome 1996.

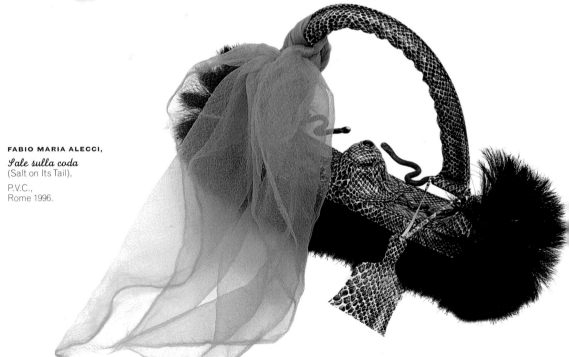

ROSSELLA RUDILLOSSO,

Sogni nel cassetto
(Hope Chest),

wood,
Milan 1996.

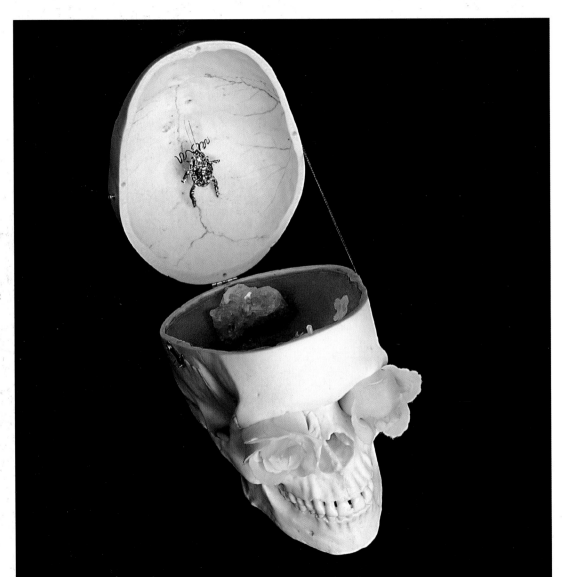

Anthropo-
BAGS

PRECEDING PAGE

MICHAEL CELENTANO,

Death Celebrations,

plastic, mixed materials,
Columbus, Ohio, 1996.

OPPOSITE

FLAVIA SOUZA,

Vera pelle
(Genuine calf),

plastic,
Brazil 1996.

FRANCESCA MONTINARO

Smart bag,

mixed materials,
Milan 1996.

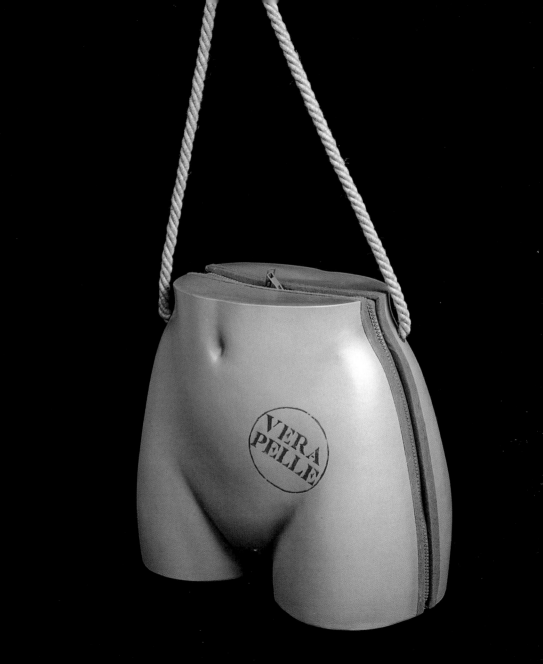

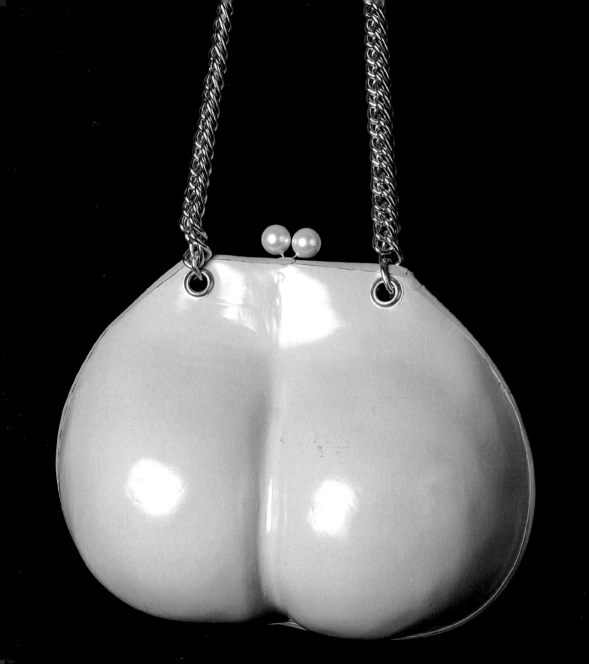

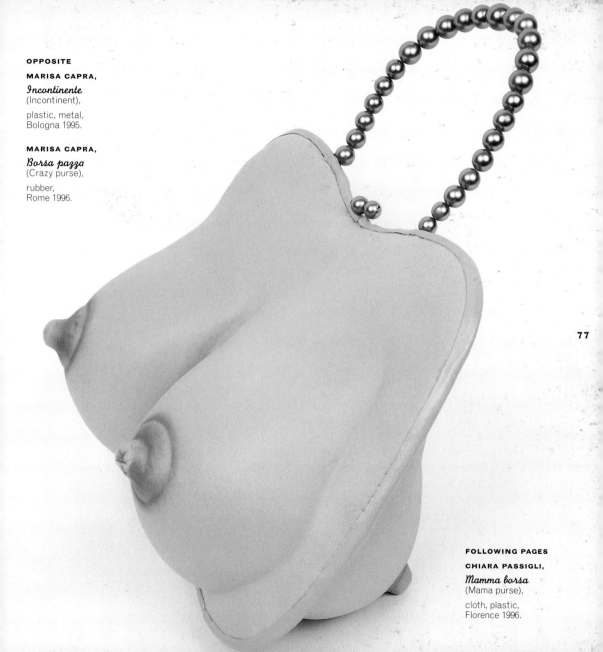

OPPOSITE

MARISA CAPRA,

Incontinente
(Incontinent),

plastic, metal,
Bologna 1995.

MARISA CAPRA,

Borsa pazza
(Crazy purse),

rubber,
Rome 1996.

FOLLOWING PAGES

CHIARA PASSIGLI,

Mamma borsa
(Mama purse),

cloth, plastic,
Florence 1996.

PAULA PINTO,

A misura d'uomo
(Human-sized),

painted canvas, leather,
Ibiza 1995.

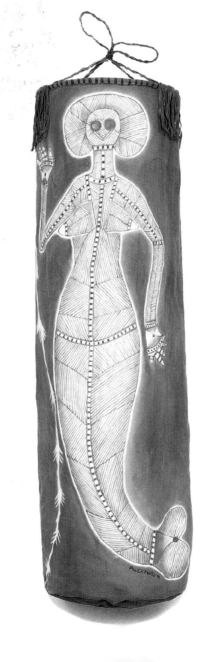

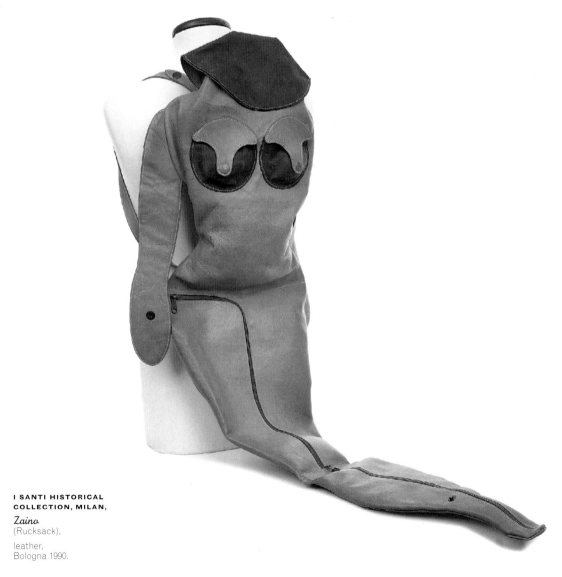

I SANTI HISTORICAL COLLECTION, MILAN,

Zaino
(Rucksack),

leather,
Bologna 1990.

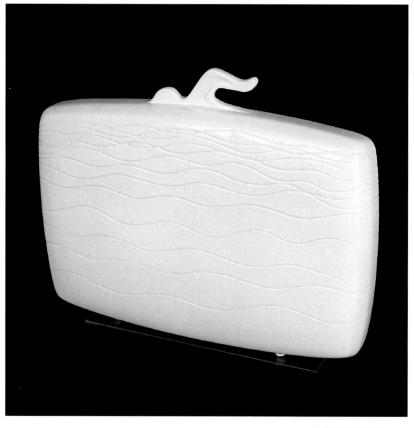

ALZEK MISHEFF,
Si salvi chi può
(Every man for himself),
ceramic,
Milan.1995.

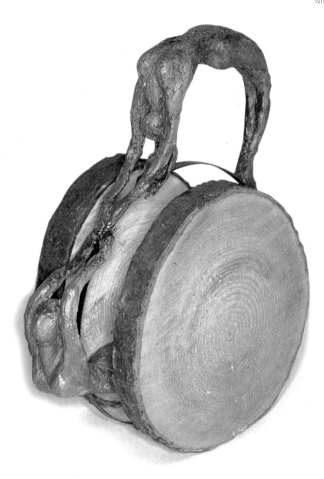

MARICA MORO,
Panta Rei,
mixed materials,
Milan 1996.

I SANTI HISTORICAL COLLECTION, MILAN,

Borsa
(Purse),

leather,
1980.

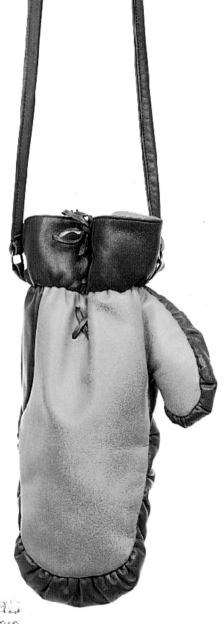

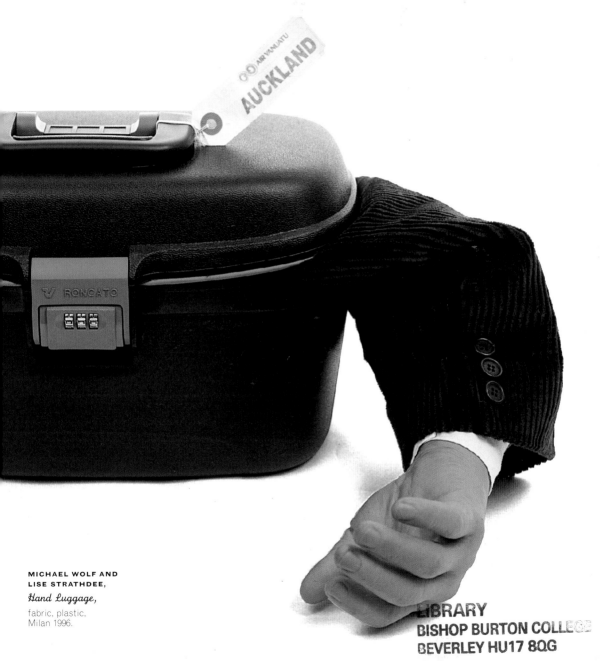

MICHAEL WOLF AND
LISE STRATHDEE,

Hand Luggage,

fabric, plastic,
Milan 1996.

JACOPO DE CARLO,

O la borsa o la vita
(Your purse or your life),

silicon, cord,
Milan 1996.

ENRICA GIUBELLI,

Atomi e DNA
(Atoms and DNA),

rubber, fabric,
Loano (Sv) 1996.

FIORUCCI,

Cuore caldo
(Warm heart),

rubber,
Milan 1996.

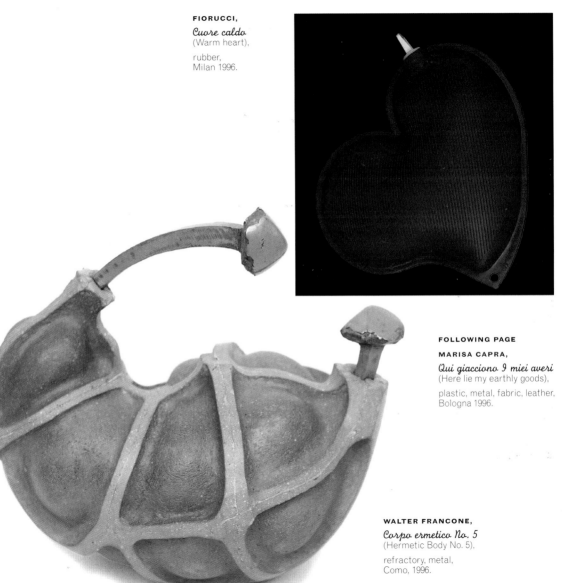

FOLLOWING PAGE

MARISA CAPRA,

Qui giacciono I miei averi
(Here lie my earthly goods),

plastic, metal, fabric, leather,
Bologna 1996.

WALTER FRANCONE,

Corpo ermetico No. 5
(Hermetic Body No. 5),

refractory, metal,
Como, 1996.

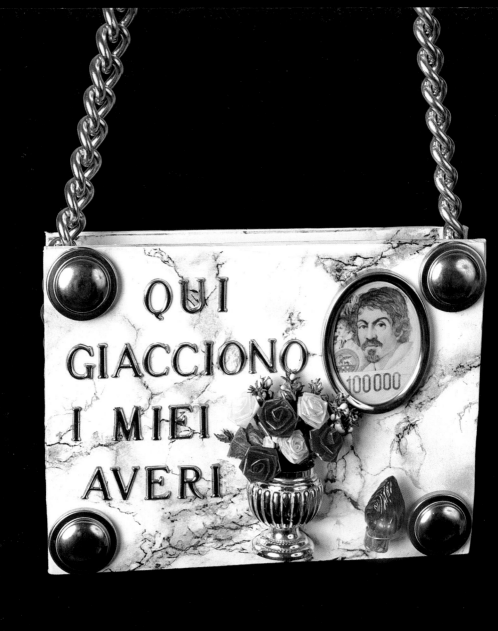

Utopia and
I R O N Y

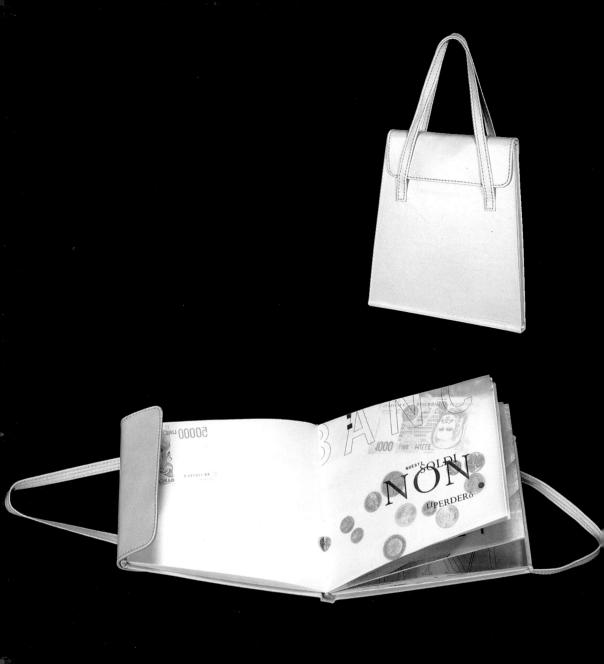

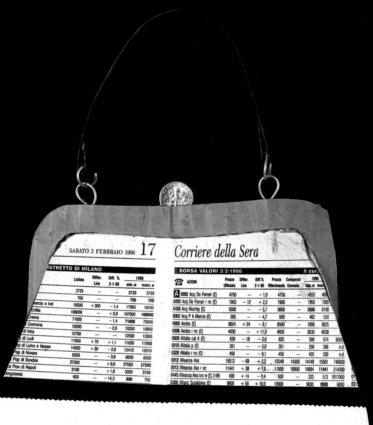

ADRIANO GIANNINI,

La borsa del tempo
(The purse of time),

leather, paper,
Florence 1996.

NENAD JOVANOVIC,

Mi tierra,

cardboard,
Florence 1995.

92

PRECEDING PAGES

SABINE LERCHER,

Borsario A–Z
(En-sack-lopedia A–Z),

leather, paper, cardboard,
Bolazno 1996.

ROSA FIOR,

La bourse de France,

paper,
London 1996.

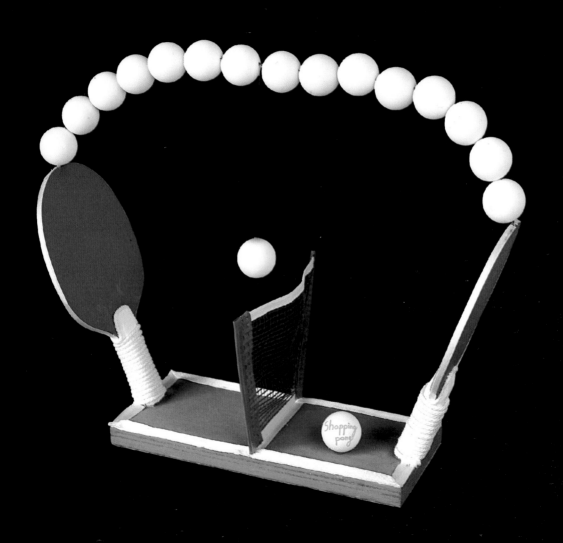

SILVIA MONTORSI,

Contenitore di primavere
(Spring container),

plastic,
Florence 1996.

A. & G. GRIMOLDI

Appuntamento
(Date),

plastic, metal,
Varese 1996.

STELLA LEVAK,

(S)componibilia
(Modular Design),

jersey,
Pula, Croazia 1995.

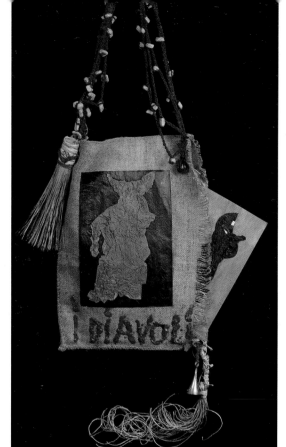

ISADORA D'ORLANDO,
La borsa dello Sciamano
(The Shaman's bag),

jute,
Milan 1995.

PEPPINO CAMPANELLA,
O la Kelly o la Klava
(Give Me Kelly Bag or Me
Klub You),

stone, glass,
Bari 1995.

FRANCESCO SCATENA,
Untitled,
paper,
Florence 1996.

From Cleopatra to Mary Poppins

ANTONIO MIREDI

Accompanied by Apollodorus, one of her confidants, Cleopatra took a small boat and came before the palace walls by night. Having no other means of entering unseen, she lay down full-length in one of those leather sacks in which rugs are wrapped. Apollodorus then tied up the sack with a strap and passed through the gates, thus bearing Cleopatra to Caesar.

"It is said that this stratagem, conceived by Cleopatra to gain access to him and proving her an intrepid woman, already captivated the Roman. His subsequent meeting with her, and the fascination of her society, ended by subjugating him utterly."

The tale of the first encounter between the last queen of Egypt and the Roman general, which entered into legend with Plutarch's fluid and realistic narrative of the carpet stratagem, presents a primitive piece of luggage as the "place" and "formula" for a voyage and an artifice—in a word, for a seduction.

"A leather sack with straps to wrap rugs and blankets in" was still one definition for a bag in Italian dictionaries up to the first decades of the present century.

Cleopatra's beauty—she was then in the full radiance of her twenty years—may have troubled the mature man, but it was her intelligence and creative wit that finally vanquished the political general.

In the dark of night, having slipped secretly across the waters of the sea, Cleopatra appearing before Julius Caesar, desired body of desire, has the same enchantment, intrigue, and potential for surprise inherent in a partly opened suitcase.

"I awoke one morning and found myself famous" is the most famous saying of poet and celebrity George Gordon Byron.

But could such *fame* have existed in an era and amid a public that was not already *famished* for travel and discovery?

At any rate, the morning in that fateful phrase was March 10, 1812—the day on which Byron's astute publisher launched *Childe Harold's Pilgrimage* on the market. It is the story of a grand tour from Occident to Orient, through a Europe in ferment, uncomfortably poised between the desire for peace and the need to seek a new equilibrium by redeeming nations from captivity.

An outcast from society: This is the fundamental nature of the man who desires to live out his passions to the fullest, and the fundamental nature of the Byronic hero. Solitude and flight are the raw materials of the paradox of romantic artist and successful author. But how marginalized could Byron really have been, with all of society vying for his presence?

The answer apparently lies in the fact that his presence presupposed an absence. "Then loathed he in his native land to dwell/Which seemed to him more lone than Eremite's sad cell."

Byron would end his brief life in far-off Greece, at Missolonghi, a participant in the Greek insurrection.

At the Historical and Ethnological Museum in Athens you can have your own personal encounter with the place-formula that accompanied Byron as he roamed the frontiers of adventure and ethical choice in the mask of the dandy and hero: a trunk, with the camp bed on which Byron exhaled his last breath.

On the other hand, at Charleville in the Ardennes, where he had fled as accursed poet and exiled angel, and where he would return as a great invalid, you can see the bag of Arthur Rimbaud.

It is preserved, a curio and relic, in the city's old mill, now the Rimbaud Museum.

It is a leather suitcase, sunburned and consumed by the dust of time.

It has the same tortured look as a consumed body.

"Finding the place, finding the formula" was the urgent imperative of Rimbaud's season in hell, which drove him to explore, in Africa, zones hitherto untouched by the white man.

Le mal d'Afrique was not yet a fashionable cultural pretext for a tourist voyage. Was his poetry silenced, or did it become a poetry that insinuated itself into the silence of a heated desert, of an immense starry sky, of a moon that knows the shadows of infamy?

Fate decreed one of its cruel ironies: The man with winged soles, the great walker, now devoured by a cancer in his knee, paralyzed, is forced to have himself carried down to the port to take ship for home, on a combined litter and trunk designed by Rimbaud himself.

A litter-trunk-bier is redrawn for a delicate and tragic watercolor, an hommage to Rimbaud on the centenary of his death, by an artist of the distant journey, Hugo Pratt.

The bag-trunk-suitcase becomes the place and formula for marvels, surprises, invention, but also mystery, fear, death. Is death not perhaps the ultimate voyage?

Setting off for foreign countries, on the other hand, was once a passage through innumerable perils.

But has anything really changed? Are death and terror concealed in a suitcase? Going forth on a journey, or any departure, was once reminiscent of the last viaticum, enough so that it was preferable to draw up one's will for the occasion.

The German verb for "to travel"—*reisen*—preserves this sense of danger in

the related lexeme *Reisige*: "a soldier of fortune": War and conquest, adventure and the risk of death. German culture has known how to transfer the etymological "place" into a narrative "formula."

In *Death in Venice* Germany's greatest author, Thomas Mann, tells us of the perils of a journey, of a seduction experienced through a journey, of absolute desire that leads to death when a journey proves fateful.

"Leaving seems to the sufferer impossible, remaining seems no less so. Thus torn in mind, he enters the station. He is very late, there is not a moment to lose if he wants to catch the train. He wants to and does not want to. But time presses, it lashes him on; he hastens to buy his ticket, and amid the tumult of the hall looks about for the hotel's agent posted here. The man appears and reports, yes, the large trunk has gone already. 'Gone already?'"

When von Aschenbach, the protagonist artist of Mann's tale, learns that his luggage has gone astray, an extravagant joy overwhelms him.

"An incredible gaiety quaked within him, almost like a spasm."

The sending astray of a piece of luggage becomes the place and formula for a desire, a new adventure, because it was loaded with an "identity" now abandoned to the formula of a destiny—in fact, an unforeseen journey.

The bag that one of his few remaining devoted friends, [Reginald] Turner, gave Oscar Wilde on the day after the writer was released from imprisonment at forced labor in Reading Gaol, was certainly not a bag filled with dreams.

It contained some essentials of personal linen, a small library, and a silver toilet kit, the sole nostalgic memento of a life he had lived beyond his own means and common morality.

A life imitating art. This time the suitcase in question had lost all joy in life,

since the flight was no longer undergone in order to pursue another identity.

He no longer had an identity. In France, a room had been reserved for Oscar Wilde under the pseudonym Sebastian Melmoth.

A Christian martyr (though still suffused with seduction), and the name of a gothic tale by Wilde's maternal uncle, [Charles] Maturin: *Melmoth the Vagabond*. A tale transmuted into *roman noir*, the delirium of beauty cast out by social condemnation, just as had happened in the metamorphosis (a journey of the soul) in *The Portrait of Dorian Gray*.

Sigmund Freud's *The Interpretation of Dreams* (that revolutionary voyage of exploration into the labyrinth of the psyche) appeared very shortly before the deaths, at the start of the new century, of two radical spirits: Oscar Wilde and Friedrich Nietzsche. What secrets lie concealed in the baggage of all such restless travelers? Is the artistic adventure of the nineteenth century conceivable without Wilde, Nietzsche, Freud?

Art has *become* the place and formula for a voyage, at times delirious, at times unmasking, always more and more unnecessary, "unnatural." Like a bag that has lost its original and essential value as an instrument of transport, a container for useful and indispensable objects, it has become other, the place and formula for a fantastic invention.

The most bizarre, most incredible, most unlikely bag (and yet still necessary) belongs to a fantasy story written by a woman, P.L. Travers. Her *Mary Poppins* is the story of a magical nanny who appears with a strange carpet-bag (and here we are again at the carpet-bag of Cleopatra—does "the bag make the woman?") apparently empty, yet anything might emerge from it.

"Then the shape, tossed and bent under the wind, lifted the latch of the gate, and they could see that it belonged to a woman, who was holding her hat on with one hand and carrying a bag in the other. "

By this time the bag was open, and Jane and Michael were more than surprised to find it was completely empty.

"'Why,' said Jane, 'there's nothing in it!'

"'What do you mean—nothing?' demanded Mary Poppins."

Exactly: What is *nothing*? Something that can't be seen, but still exists?

Something that others have not seen, but is there anyway?

Fantasy: A place and formula for artistic artifice.

The house where Mary Poppins arrives is normal and bourgeois. The father, Mr. Banks, is terribly busy making money: "All day long he worked, cutting out pennies and shillings and half-crowns and threepenny-bits. And he brought them home with him in his little black bag."

Another bag, but full, heavy, real!

Yet unable to make anyone *fly*. And back to mind comes the "empty" bag in De Sica's film *Miracle in Milan*, based on Cesare Zavattini's story *Totò the Good*.

A bag stolen by a tramp not for what's inside, what it contains, but for what it is, a "beautiful suitcase," a place-formula that is an end in itself. And which in fact opens up a voyage into the impossible.

It says something when a master of neorealism proves to be just as much a poet of the fantastic! Adventure, games, nonsense are also part of life. As long as the wind is favorable.

"'I was only saying,' began Michael, meekly, 'that we hoped you wouldn't be going away soon—' He stopped, feeling very red and confused. Mary Poppins stared from him to Jane in silence. Then she sniffed.

"'I'll stay till the wind changes,' she said shortly, and she blew out her candle and got into bed."

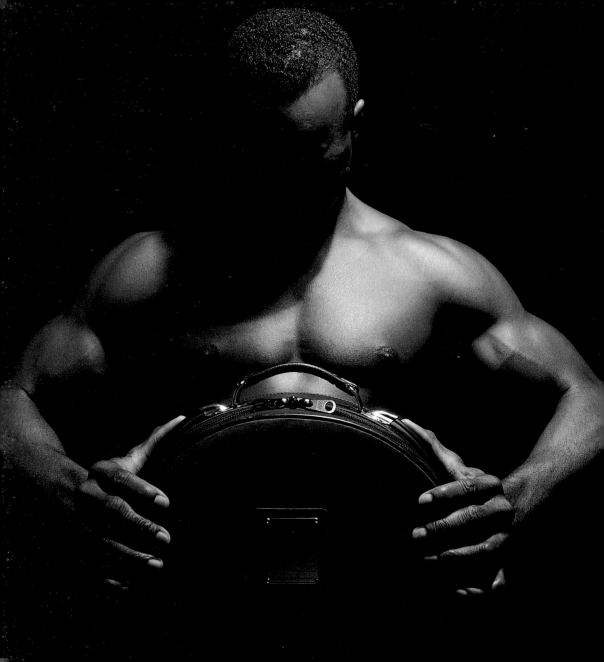

Meta-
PHORS

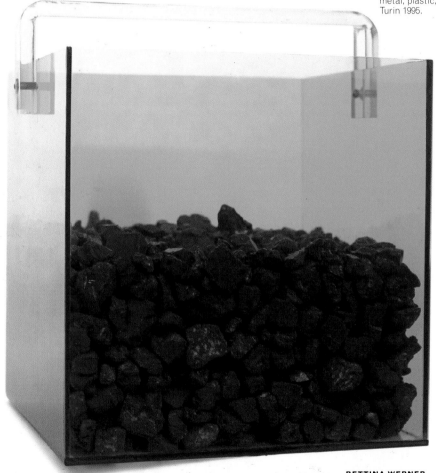

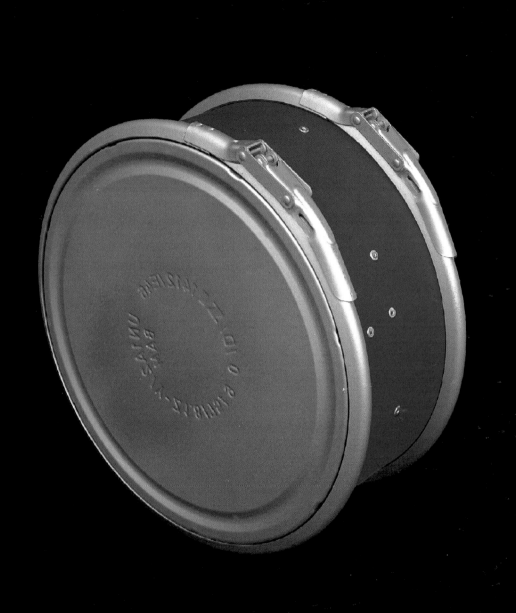

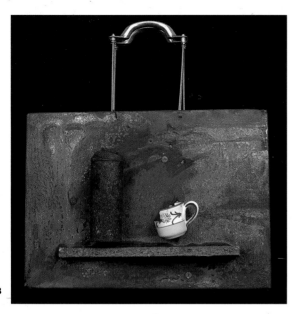

OPPOSITE

LORENZA BRANZI AND CHRIS REDFERN,

Mrs. Kass,

bark,
Milan 1996.

ANTONIO FINI,

Borsa naturamortosa
(Still-life purse),

iron, ceramic,
Bari 1996.

CANDIDA FERRARI,

Arte quotidiana
(Everyday Art),

Plexiglas,
Parma 1996.

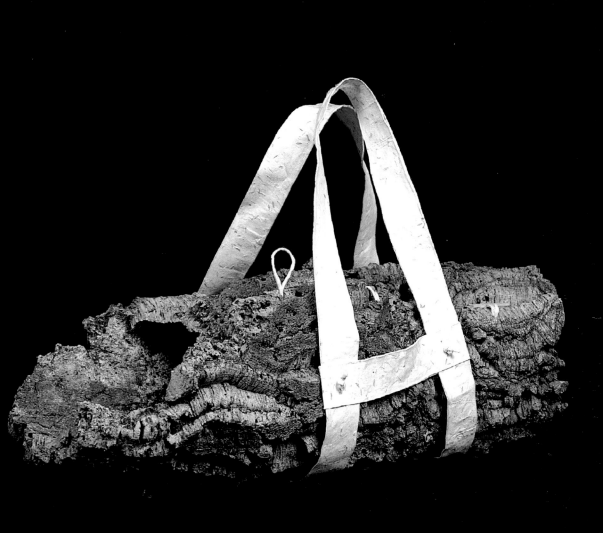

110

ELIO MARCHEGIANI,

Le mie aste da viaggio
(My traveling sticks),

leather, fresco,
Bologna 1996.

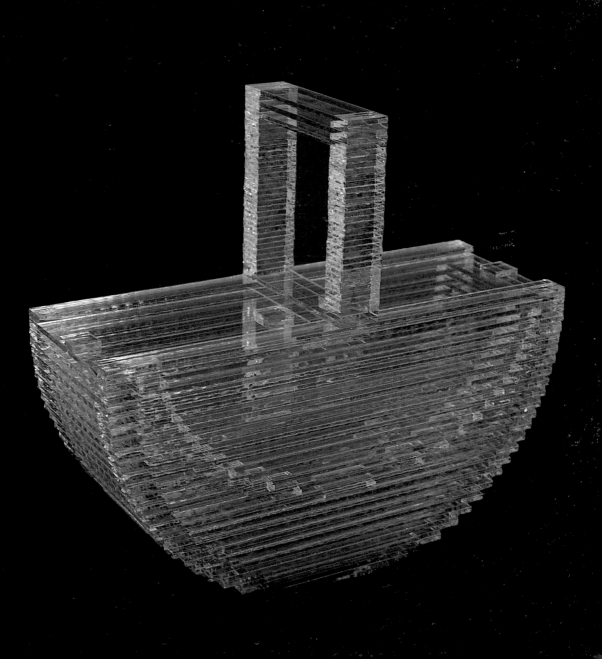

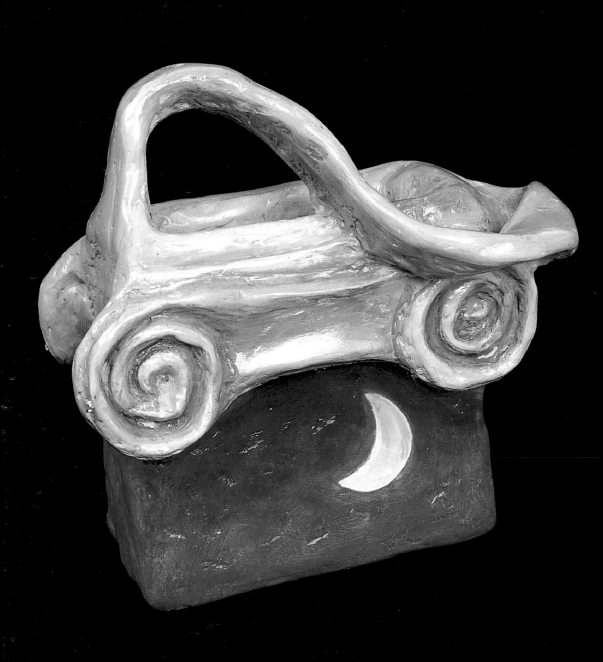

DANIELA DAVOLI,

Rivelatore 1
(Revealer 1),

mixed materials,
Bologna 1996.

INBAL GERSHGOREN,

Equilibrio
(Equilibrium),

P.V.C.,
Piacenza 1996.

OPPOSITE

MARIA TERESA PADULA,

Classica da sera
(Evening Classic),

plaster of paris, wire mesh,
Bari 1996.

OPPOSITE

FRANCESCO SIANI,

Borsetta piena di sogni
(Purseful of dreams),

marble, copper,
Carrara 1996.

CORRADO BONOMI,

Borsa da asporto
(Take-out purse),

cardboard,
Novara 1996.

Grovso 'gr̄ '86
xx secolo

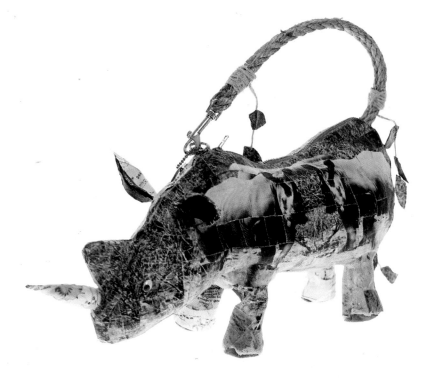

STEVEN LOWY,

Rhino Handbag,

mixed materials,
New York 1996.

Wild
BAG

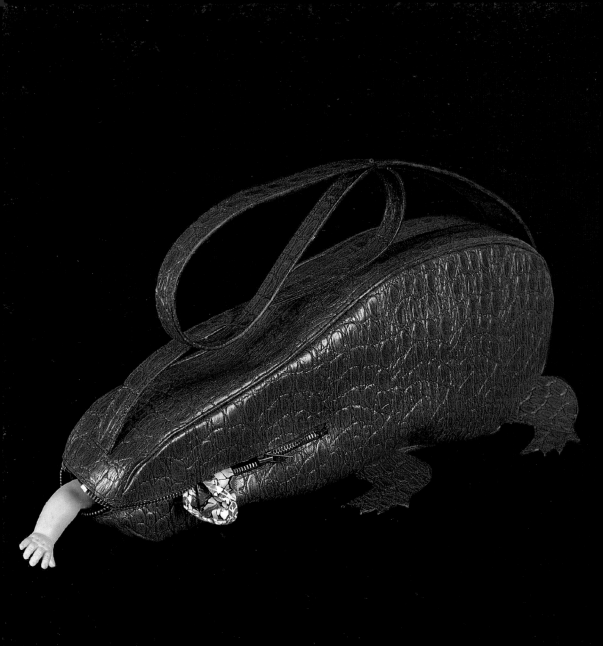

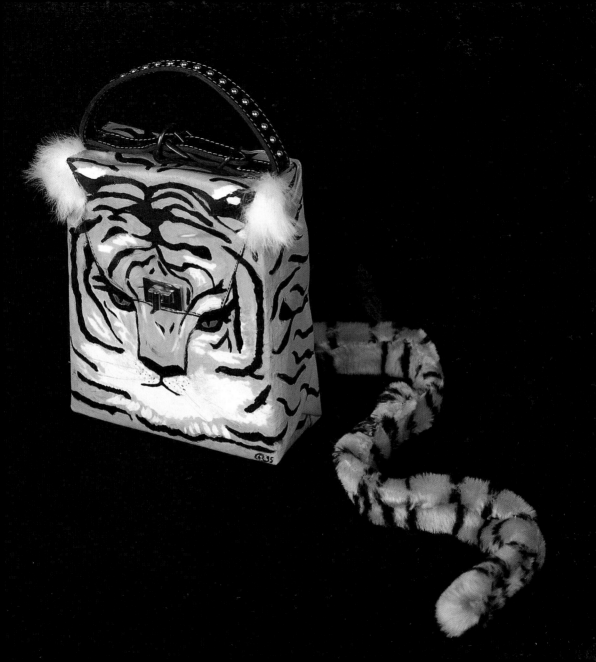

CLAUDIA LANDI,
Paperino
(Donald Duck),

ecological fur,
Florence 1996.

PAOLO TRAVERSARI,
Lola,

ecological fur,
Florence 1996.

PRECEDING PAGES

CAROL LIPTON,
Crocodile Tears,

leather,
Paris 1995.

CLAUDIA BARAZZUTTI,
Marpessa,

canvas, ecological fur,
Milan 1996.

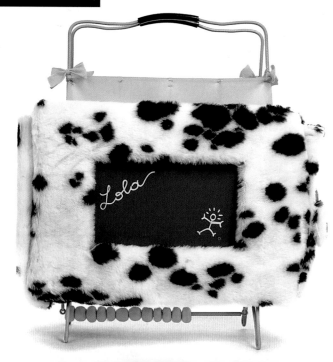

SARA IRENE,
Profumo d'arancio
(Scent of Oranges),

fruitpeels,
Udine 1996.

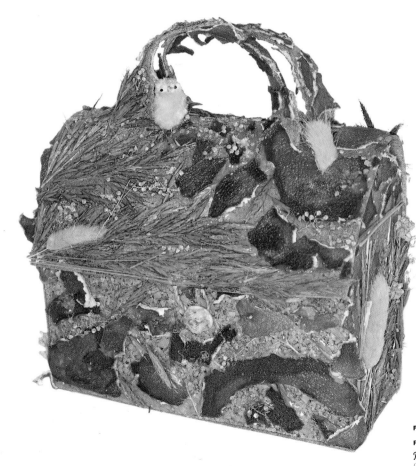

FOLLOWING PAGE

PIETRO SILVA,
Porta palude
(Swamp carrier),

crystal, metal,
Milan 1996.

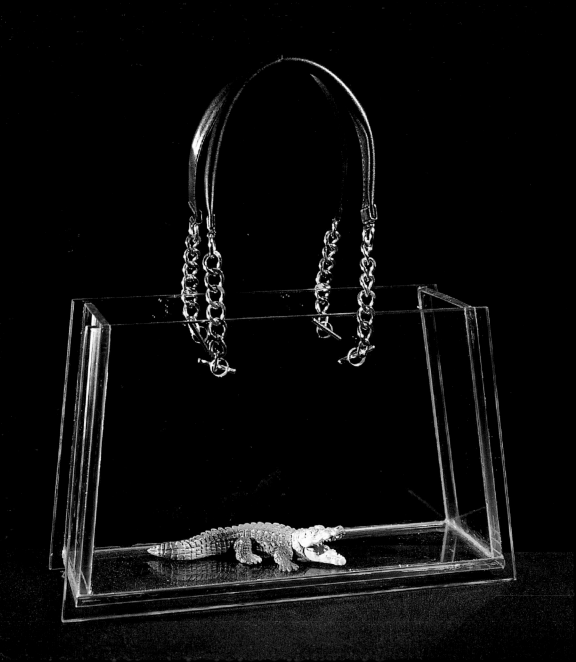

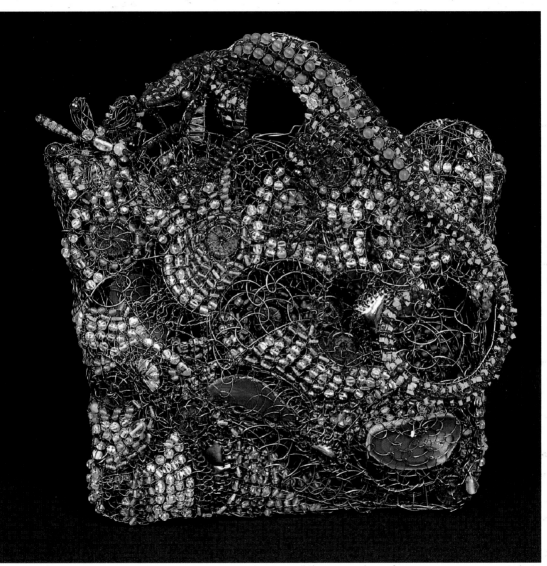

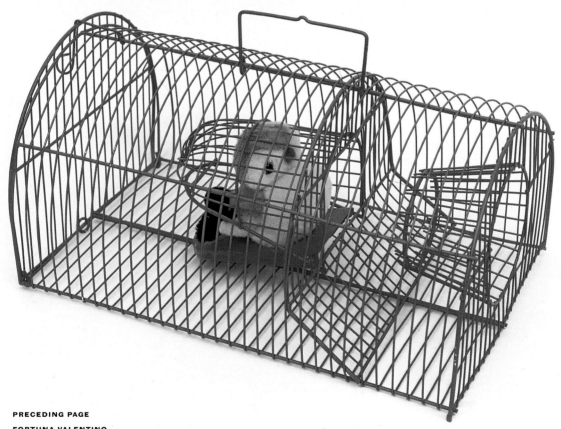

FABIO ROTELLA,

Porta passera
(Sparrow carrier),

metallic cage, feathers,
Milan 1996.

PRECEDING PAGE

FORTUNA VALENTINO,

Borsa Sue Hort
(Sue Hort Purse),

net, filigree, colored stones,
Milan 1995.

PIETRO RUSSO

La casa delle bambine smorfiose
(Little Miss Priss's House),

sheet metal, Plexiglas,
Florence 1995.

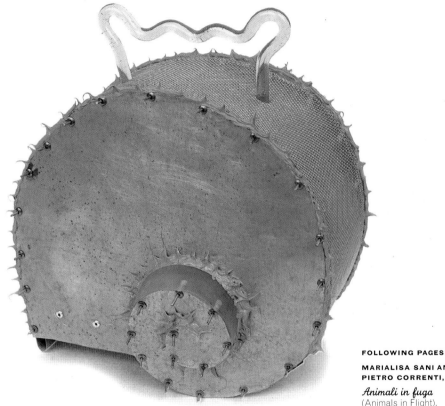

FOLLOWING PAGES

**MARIALISA SANI AND
PIETRO CORRENTI,**

Animali in fuga
(Animals in Flight),

paper mache, net, chalk,
Florence 1996.

MIYO YOSHIDA,

Dino-Dinino,

metal, glass,
Milan 1996.

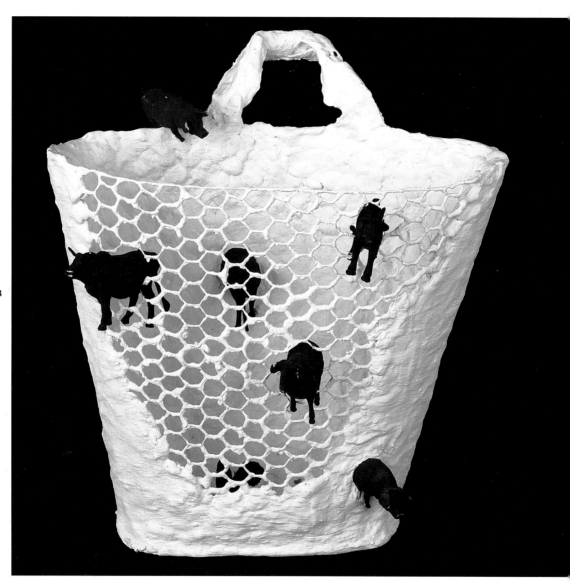

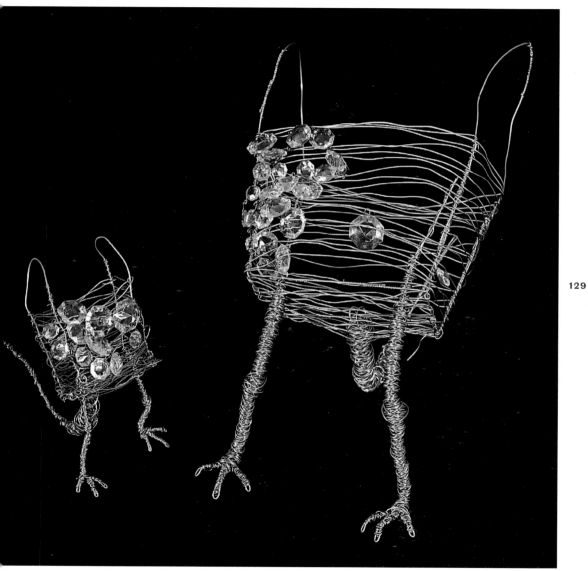

**MARCO LUCIDI PRES-
SANTI,**

Untitled,

ecological fur,
Florence 1996.

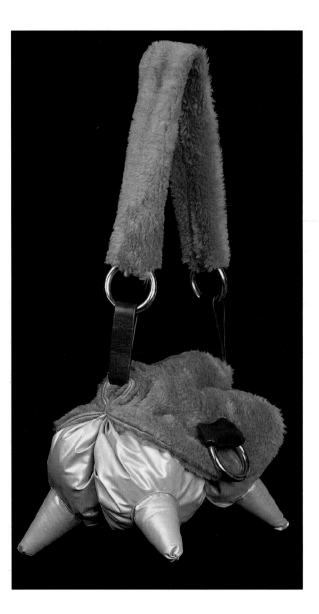

MICHELA DELLE DONNE,
Titti,
feathers, metal, cord,
Milan 1996.

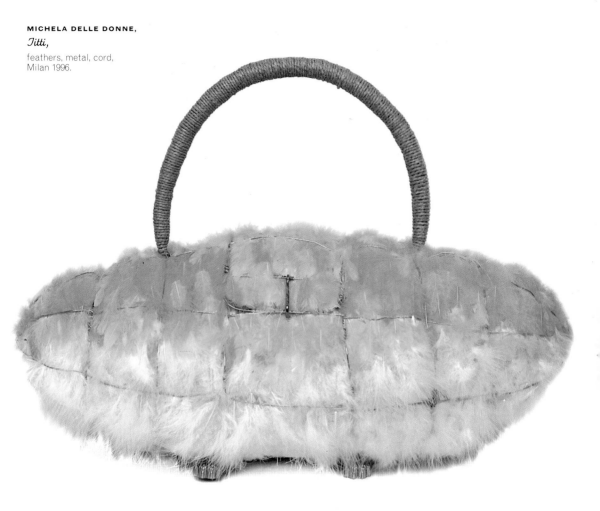

FOLLOWING PAGE
*New York, Christmas
1995*
photo: Wahb Mabkhout.

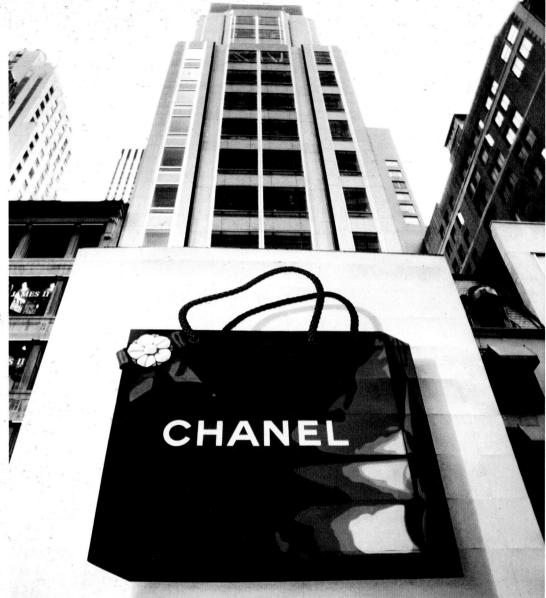

Shopping
BAGS

LUCA BACELLI,
Wigghy Wigh's Bag,
acetate, cardboard,
Milan 1996.

134

New York

Shopping Bags,
paper,
1996.

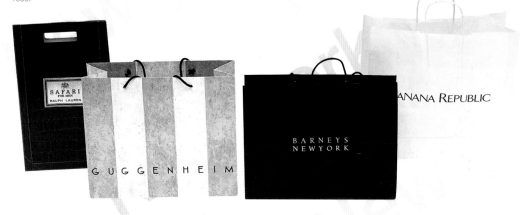

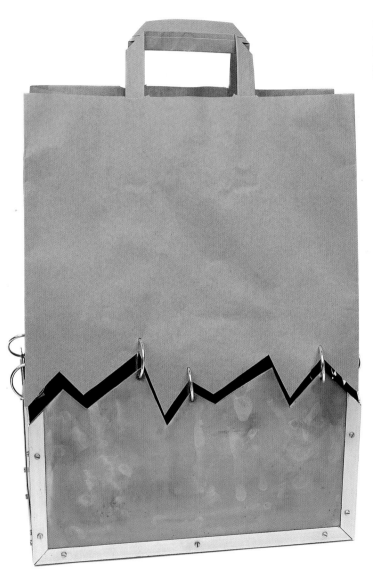

OPPOSITE

LILLO MILICI,

Made in Italy,

pasta, cord,
Florence 1996.

London

Shopping Bags,
paper,
1996.

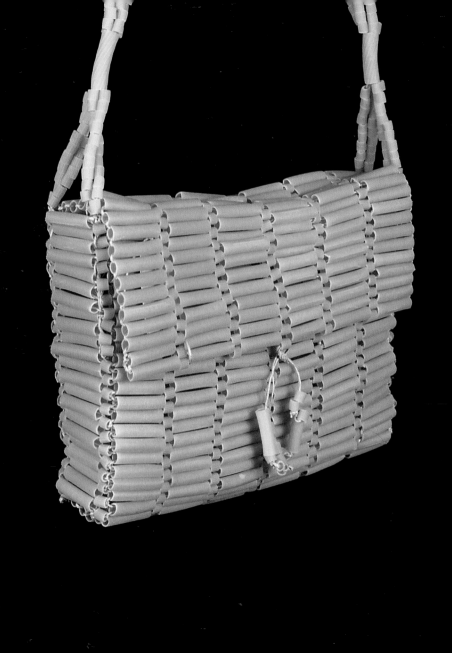

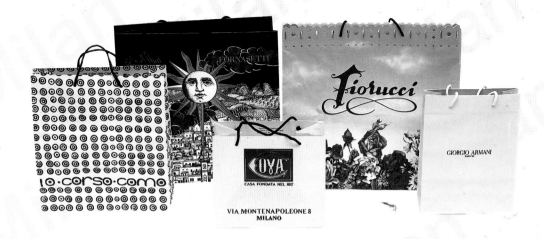

Milan

Shopping Bags,
paper,
1996.

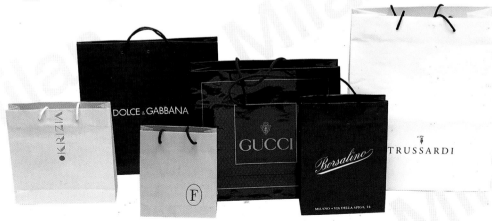

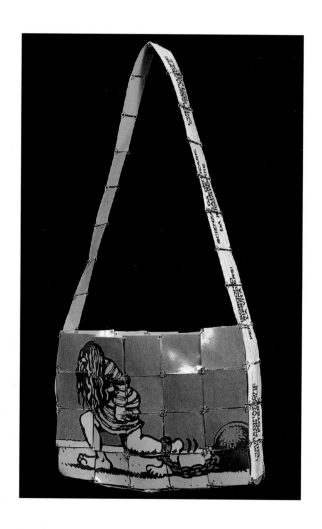

GINA LAROCCA,

Immaginazione
(Imagination),

plasticized paper,
Rome 1996.

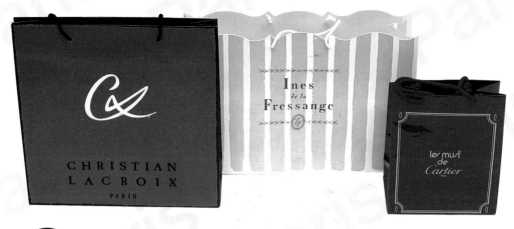

Paris

Shopping Bags,
paper,
1996.

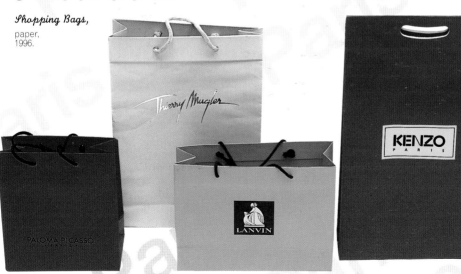

ALFONSO SIRACUSA,

Contenuto prematuro
(Untimely Contents),

gesso / plaster of paris,
Agrigento 1996.

Suit-

CASES

Self-portrait in a Suitcase

MARCO MENEGUZZO

When Marcel Duchamp, in 1941, announced he had finished his "Boîte-en-valise" (literally, the "Box in a Valise"), on which he had been working for more than six years, he was well aware of having, so to speak, summarized his entire life in a little suitcase measuring forty centimeters on a side. The famous Duchampian container, in fact, contained sixty-nine Lilliputian reproductions of the artist's works, practically the work of forty years made portable in what today we would call—the irony of names—an overnighter.

Yet what counts here is not so much the aspect of time, in which an entire life can be summarized in a bag that usually confers autonomy for a day (indeed for some people, a page of an appointment book, and perhaps not even not too large a one at that, would be enough to contain the major events of their existence). What is really important is another aspect, which also characterizes a large number of the selections at work in this "In the Bag" show: The bag, or rather its contents, is a self-portrait of its owner.

Self-portrait, because a bag forces us into a choice, a choice of everything that characterizes us both as a person and as a member of a group, a society, a tribe, for the near future. The suitcase—or any traveling container—is a portrait of what we are and what we want to be.

Someone may say that this pertains not to the bag but to its contents, which is true. But this show has applied a form of semantic body English—I would say that the rhetorical figures most akin to it are metonymy and synecdoche—which, by transferring to the container what it usually contains, saves us from becoming customs officers messily rummaging through people's most intimate secrets.

So the container has become the thing contained. Self-evidently, this might also be a good metaphor for art, where signifier and thing signified (some nostalgic disciple of Croce might speak of form and content) are so closely correlated that they cannot be separated without making each of them less. But let's not be excessively abstract and conceptual—in part because, far more than any other category of expression, the artistic genre of the self-portrait (and "In the Bag" fully falls within this territory) is in any case today closely linked with individuality, the singularity of choice, to what one has lived through.

Thus the critic's duty is divided, as ever, between the attempt to establish general categories and the imperative to safeguard individual expression, the particularity of individual choice. In a show with such a vast number of names, only the former option is open, since the latter is substantially impracticable.

So the suitcase is a self-portrait. But it is also—apologies for stating the obvious—a suitcase. As if to say that in art, the metaphor cannot completely replace its point of departure, the object. However much it undergoes this mutation in significance, and though it may itself be no great vehicle for suggestion or story, the object still retains a modicum of dignity qua object, which cannot be forgotten. Thus we simultaneously look at the two semantic poles, that of the self-portrait, which is the farthest from the literal thing signified by the object, and that of the suitcase, precisely as a physical object. And in between we pass through a certain number of evocative stations.

Among the easiest of these to discover in our case is the idea of the "journey."

In Italian, packing a bag is called "making a bag." So asking an artist to "make a bag" means asking him to indicate metaphorically what he needs for his adventure as an artist, which is why many of them have quite consciously packed their bags with the elements that help them to live and to make art. "Making a bag" is a meditative, a serious, a rational act, which perhaps is why those typical scenes in dramatic movies from the fifties seem just slightly ridiculous, when the heroine is threatening to leave, all the while stuffing a little bag with assorted bits of lingerie yanked furiously from a drawer. On the contrary, I have the impression that artists by far prefer the big trunk, à la von Aschenbach in *Death in Venice*: A trunk which of itself is already a kind of house, a cupboard, almost a sarcophagus, inside which one can calmly shut oneself up, safe and secure amid one's own belongings.

Yet this last example somewhat changes the perspective from which to look at many of the works that appear here. There are those who fill their bag, and those who "are" one with the bag. Of course this is a terribly risky figure of speech, yet only because the object in question does not enjoy an excess of attention, and can be considered a metaphor only in cases like this. In fact, if we assume a bag is a self-portrait, we cannot escape applying this last, subtle distinction, which paradoxically derives not from the simply physical aspect of "packing" a bag with something, or modifying its shape, transforming it—but from a conceptual and sentimental attention to the artist's intent. In other words, in all these works (which have often assumed the role of a divertissement on a set theme, an exercise in style), we must

find a way of distinguishing the intent to appear from the intent to be—without meaning to moralize in the least, and absolutely without assigning a priority to either option, but purely out of a desire to know more about the artist's preferred language.

Hence, "packing" would be closer to appearance, in the sense that the bag contains all the linguistic instruments that make it possible to communicate the image of oneself that one wants to convey, thus creating a kind of curtain, or to remain closer to our metaphor, showing off a piece of clothing one wants to wear. On the other hand, "identifying" with the bag would be closer to being (and I repeat, in art this is not necessarily the better aspect). And again, we must do all this without being able to make the distinction on immediately visible grounds—that is, without dividing those who materially put something into the bag from those who, for example, limited themselves to painting its exterior, or those who denied the bag's shape, perhaps even dismembering it, from those who have made it into a kind of totem or fetish.

In reality, in this show—to apply the metaphor for a last time—we must discover (where any exists) a hidden compartment of meaning, which in the end distinguishes the gadget from the work of art.

PAOLO COTZA,

Alta Velocità
(High Velocity),

wood, bakelite, aluminum,
Turin 1994.

MAURIZIO AGHEMO,
Tempo Internazionale
(International Time),

mixed materials, fiber suitcase,
Turin 1994.

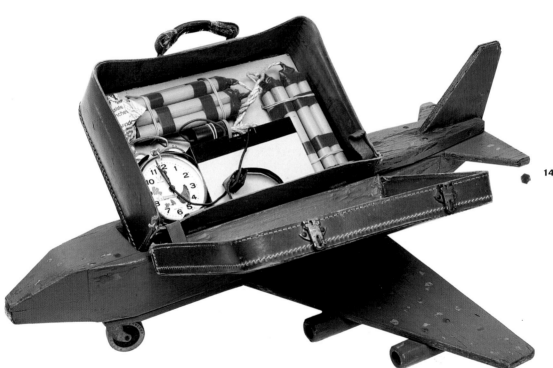

149

PLINIO MARTELLI,
Il viaggio
(The trip),
wood, velvet, leather suitcase,
Turin 1994.

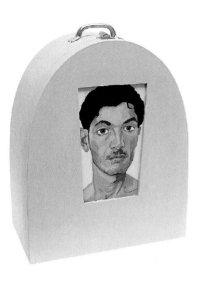

VALENTINO MARENGO,

Valigio per viaggio eterno
(Suitcase for an eternal journey),

encaustic on wood,
Turin 1994.

PAOLA RISOLI,

La valigia di millibar
(Millibar Suitcase),

mixed materials,
Turin 1994.

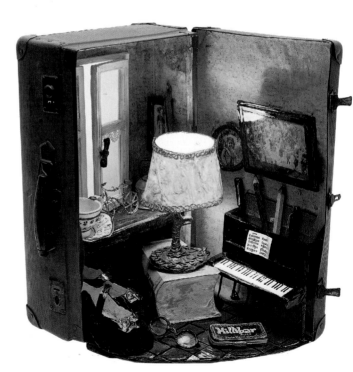

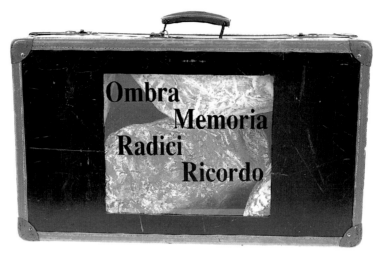

DAVIDE BRAMANTE,
Ombra, memoria, radici, ricordo
(Shadow, memory, roots, remembrance),

mixed materials, Turin 1994.

MARIO SURBONE,
Materia prima
(Raw materials),

shaped wood, fiber suitcase, Turin 1994.

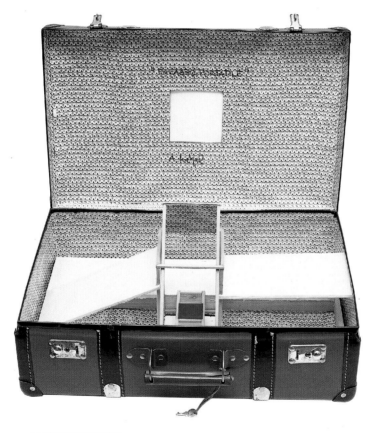

ALEXANDRA WETZEL,

Palazzo portatile
(Portable palace),

gauze, wood, fiber suitcase,
Turin 1994.

ANTONIO CARENA,

Cielaggetto
(Skyliner),

acrylic paint, fiber suitcase,
Turin 1994.

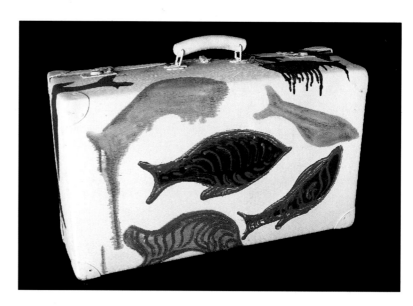

EZIO GRIBAUDO,

Carnevale Marino
(Sea Carnival),

tempera, fiber suitcase,
Turin 1995.

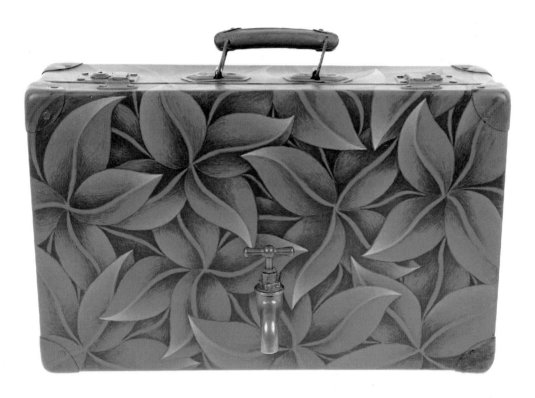

MERCURIO,

Verso il deserto
(Into the desert),

acrylic, faucet, fiber suitcase,
Turin 1994.

TITTI GARELLI,
La valigia del collegio
(Boarding school bag),

fiber suitcase,
Turin 1993.

DANIELA GOTAL,
What about corn?,

corn,
Coratia 1995.

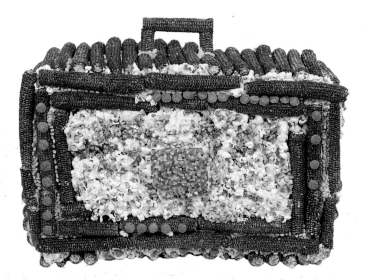

OPPOSITE

ENRICO BORGHI,
Untitled,

mixed materials,
Turin 1995.

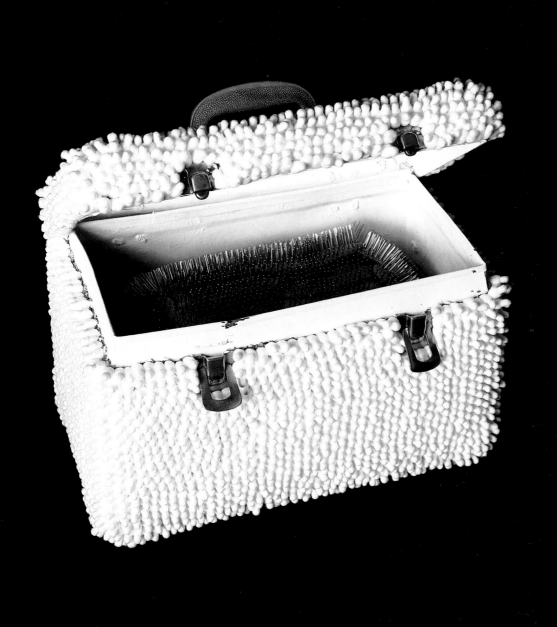

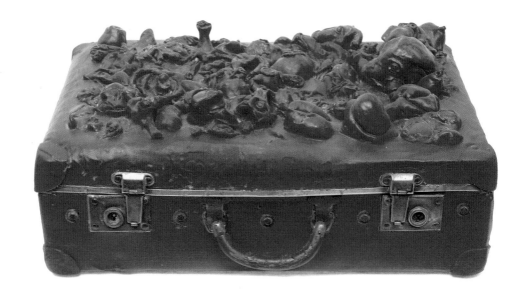

ENRICO CARGNINO,

Untitled,

acrylic, fiber suitcase,
Turin 1995.

LUISA RABBIA,
Untitled,
photo, fiber suitcase,
Turin 1993.

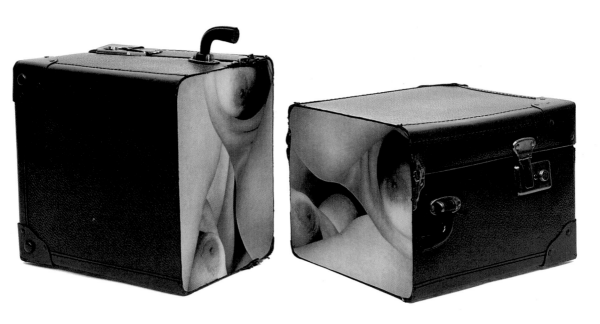

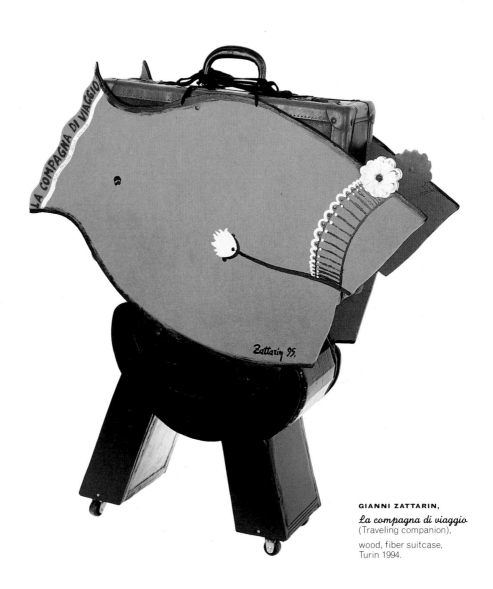

GIANNI ZATTARIN,

La compagna di viaggio
(Traveling companion),

wood, fiber suitcase,
Turin 1994.

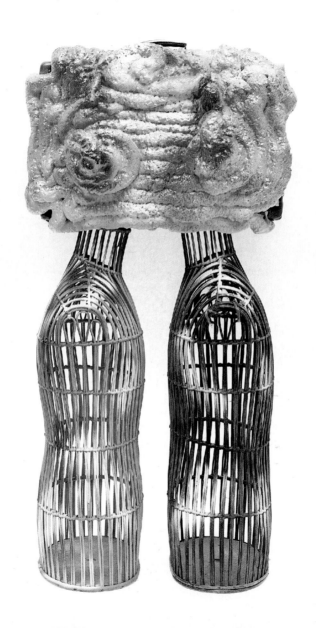

MARCO COTZA,
Untitled,
mixed materials,
Turin 1994.

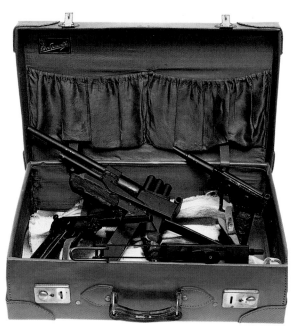

VASCO ARE,

Campionari Stagionali
(This Season's Samples),

iron, cotton, fiber suitcase,
Turin 1995.

CARLO GIULIANO,

Separazione
(Separation),

aluminum, fiber suitcase,
Turin 1995.

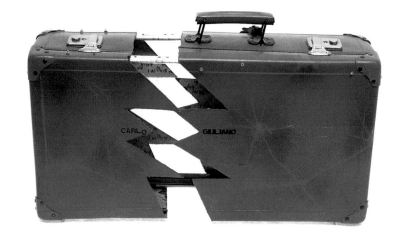

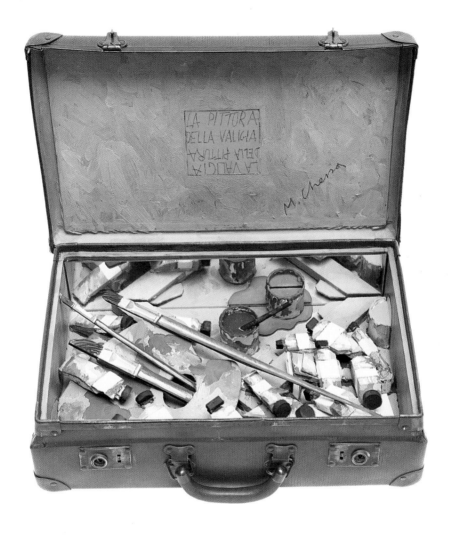

MAURO CHESSA,

La pittura della valigia
(Suitcase painting),

acrylic, fiber suitcase,
Turin 1995.

164

PAOLO PISCITELLI,

Paleocamera,

resin, graphite, fiber suitcase,
Turin 1995.

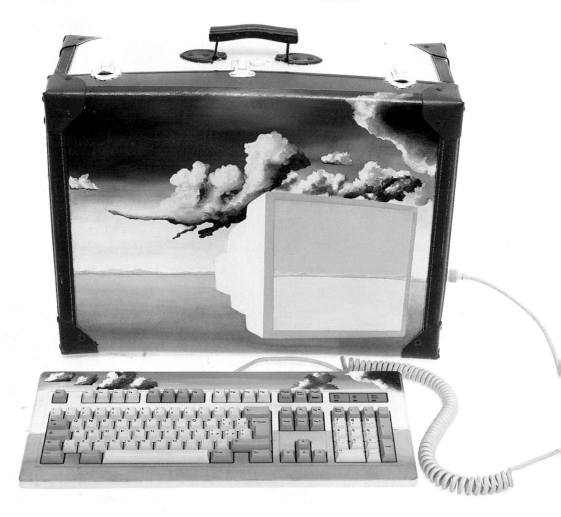

GIOVANNI FORELLI,

The End,

oil paint, keyboard, fiber suitcase,
Turin 1994.

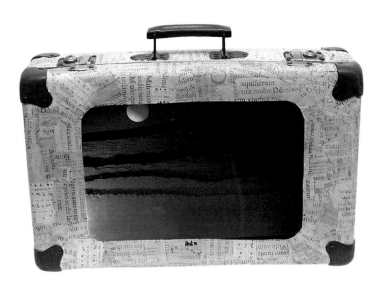

SERGIO AGOSTI,

La valigia dei sogni e dei ricordi
(The Suitcase of Dreams and
Memories),

mixed materials, fiber suitcase,
Turin 1994.

SILVIO BOSTICCO,

Andata e Ritorno
(There and Back Again),

fiber suitcase, acrylic,
Turin 1994.

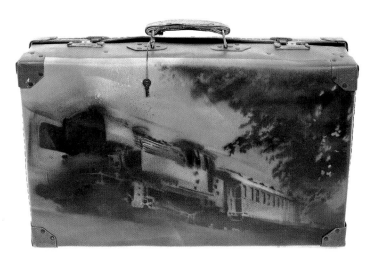

DAVID TURINI,
Il beauty di maya
(Maya vanity case),

wood,
Florence 1996.

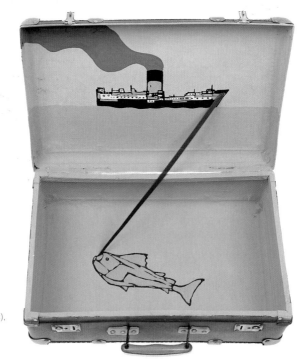

FRANCESCO CASORATI,
Pesca miracolosa
(Miraculous draft of fishes),

acrylic, ribbon, fiber,
Turin 1994.

SAVERIO TODARO,

Clic
(Click),

glass, cardboard suitcase,
Turin 1993.

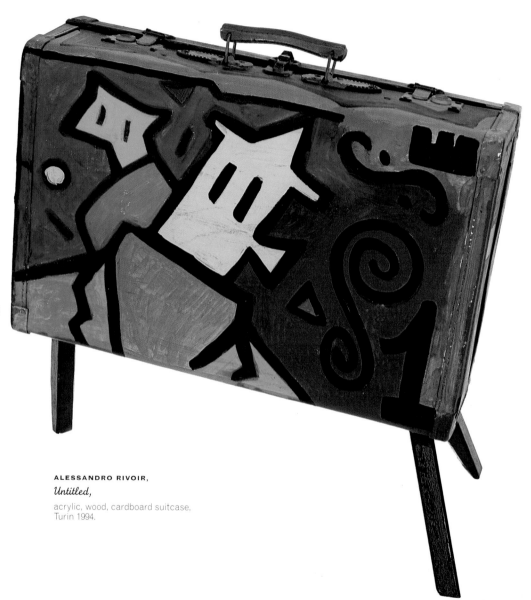

ALESSANDRO RIVOIR,

Untitled,

acrylic, wood, cardboard suitcase,
Turin 1994.

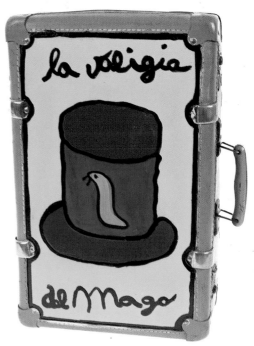

ROBERTO BOTTONI,

La valigia del mago
(Bag of Tricks),

acrylic, fiber, suitcase,
Turin 1995.

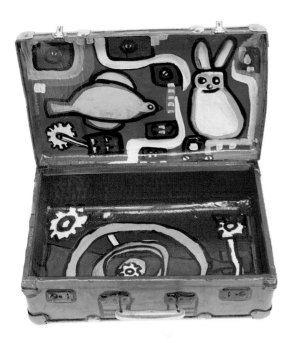

RUGGERO MAGGI,

Auschwitz,

neon, Plexiglas, barbed
wire, wood,
Milan 1996.

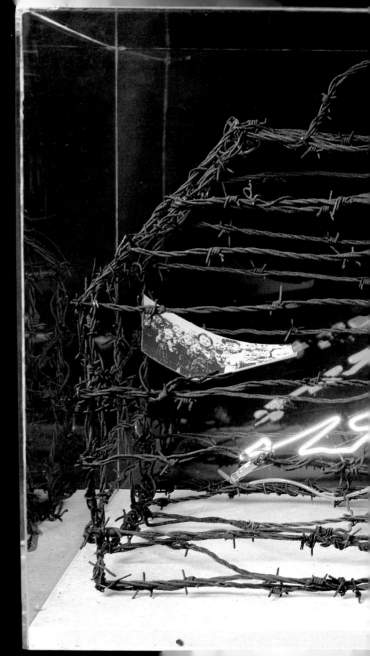

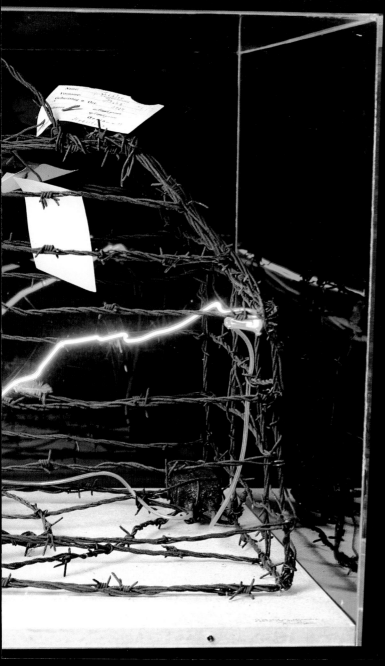

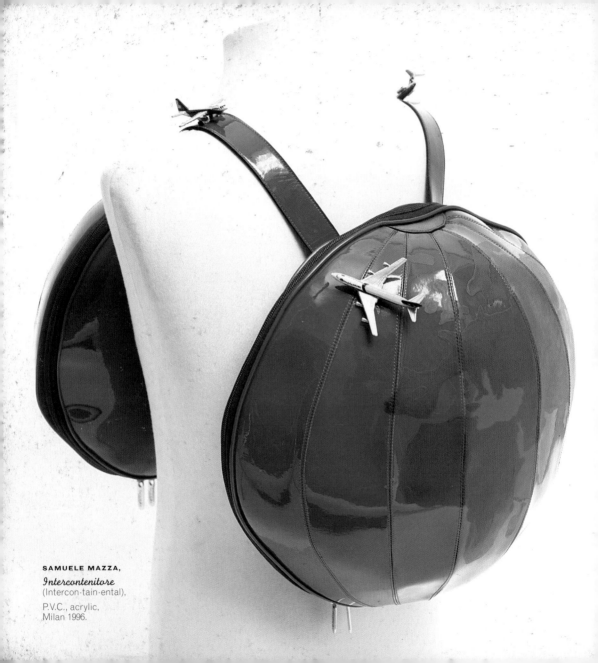

SAMUELE MAZZA,

Intercontenitore
(Intercon-tain-ental),

P.V.C., acrylic,
Milan 1996.

Front

BACK

MASSIMO IOSA GHINI,

Coccodrillo
(Crocodile),

leather,
La Fabbrica di Dedalo &
A. Guerriero Collection,
Florence 1994.

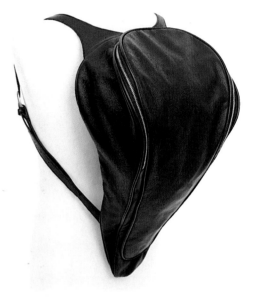

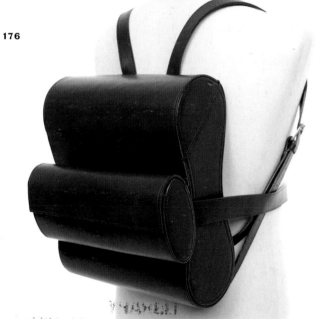

**GRISCHA GODDERTZ &
CHRISTIAN CLAER,**

Mattoni
(Heavy as bricks),

leather,
Guerriero Collection,
Milan 1994.

STEFANO GIOVANNONI,

Pericolo
(Danger),

leather,
La Fabbrica di Dedalo &
A. Guerriero Collection,
Florence 1994.

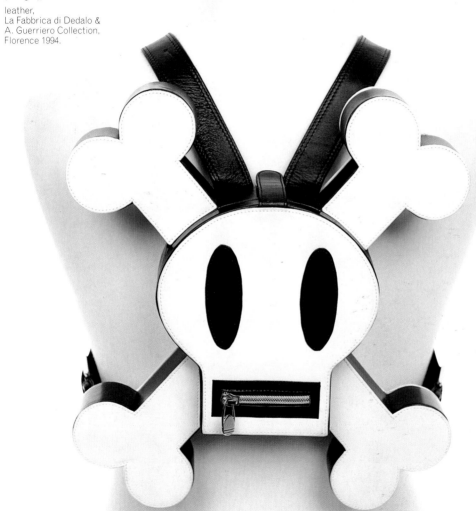

CLARA BONFIGLIO,

Bianco e nero
(Black and white),

leather,
La Fabbrica di Dedalo &
A. Guerriero Collection,
Milan 1994.

AGUSTIN OLAVARRÍA,

Ruote
(Wheels),

leather,
La Fabbrica di Dedalo &
A. Guerriero Collection,
Milan 1994.

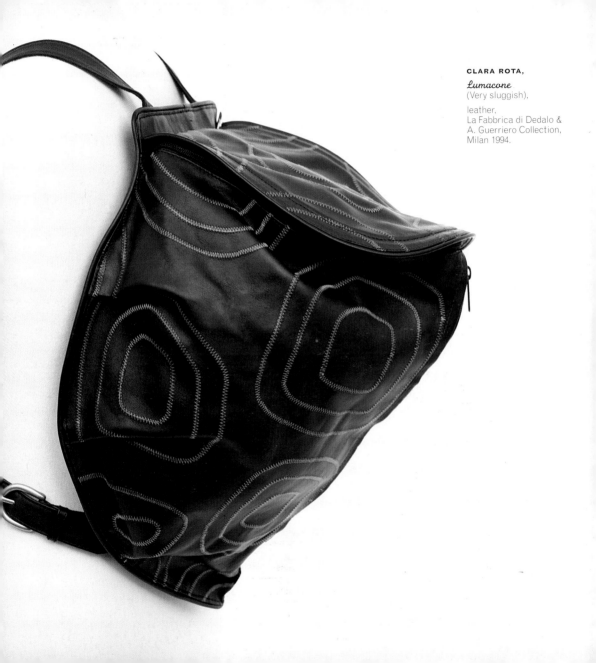

CLARA ROTA,

Lumacone
(Very sluggish),

leather,
La Fabbrica di Dedalo &
A. Guerriero Collection,
Milan 1994.

UGO NESPOLO,

Maschera
(Mask),

leather,
La Fabbrica di Dedalo &
A. Guerriero Collection,
Milan 1994.

180

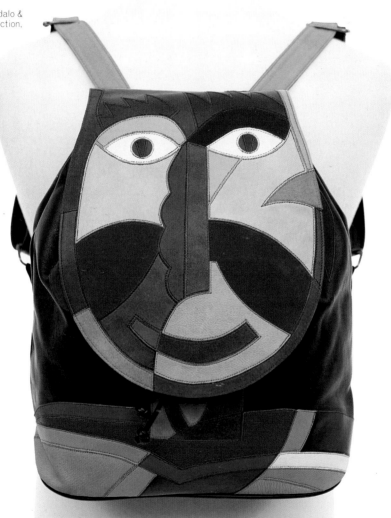

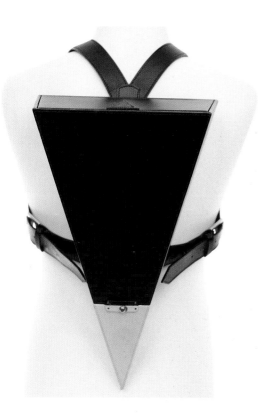

CLAUDIO REBAUDO,

Punta
(Point),

leather,
La Fabbrica di Dedalo &
A. Guerriero Collection,
Milan 1994.

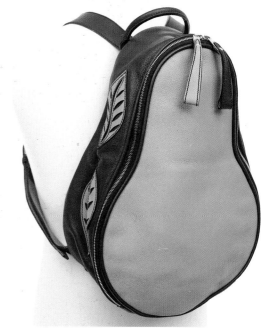

REBECCA CROSS,

Frutta
(Fruit),

leather,
La Fabbrica di Dedalo &
A. Guerriero Collection,
Milan 1994.

LUIGI SERAFINI,

Zzzzz

leather,
La Fabbrica di Dedalo &
A. Guerriero Collection,
Milan 1994.

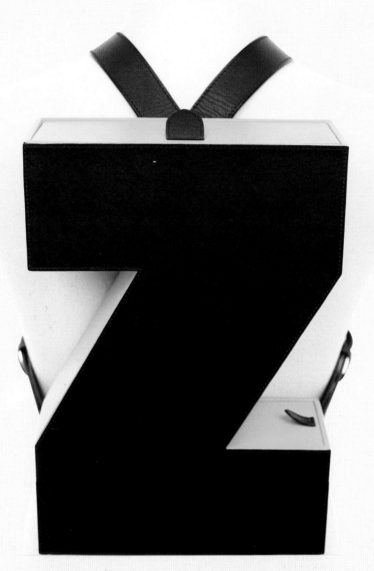

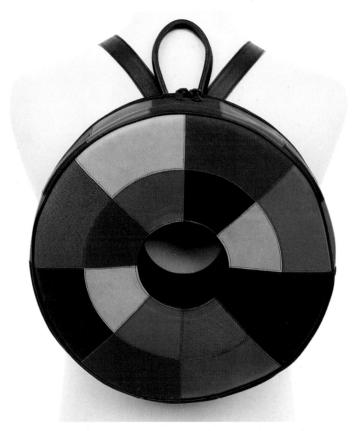

ALESSANDRO GUERRIERO,

La borsa intorno al buco
(The bag around the hole),

leather,
La Fabbrica di Dedalo &
A. Guerriero Collection,
Milan 1994.

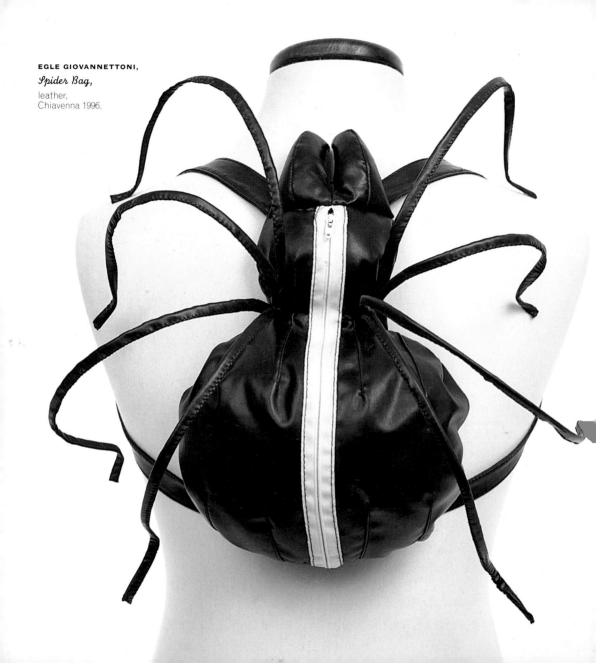

EGLE GIOVANNETTONI,

Spider Bag,

leather,
Chiavenna 1996.

REDWALL ARCHIVE,

Granchio
(Crab bag),

leather,
Bologna 1995.

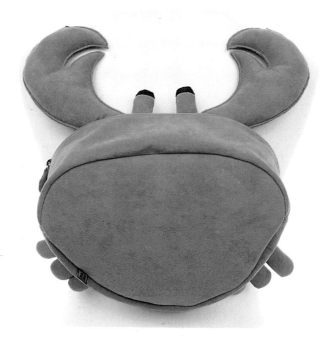

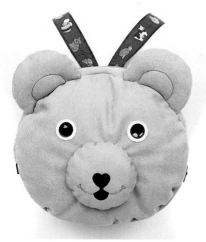

REDWALL ARCHIVE,

Orsetto
(Baby bear),

leather,
Bologna 1995.

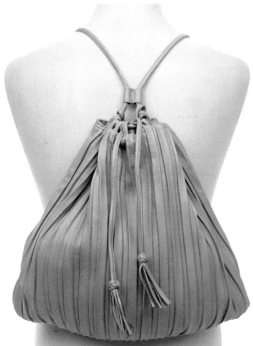

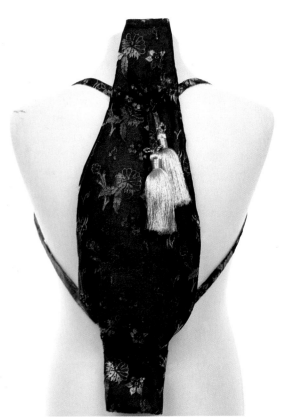

**REDWALL FOR
GIORGIO ARMANI,**

Plissé,

leather,
Milan 1995.

SANCHITA AJJAMPUR,

Bonbon,

silk,
Milano 1996

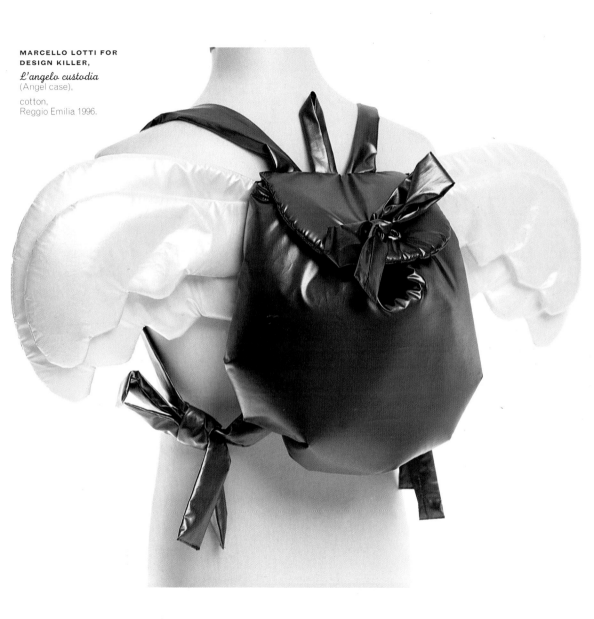

**MARCELLO LOTTI FOR
DESIGN KILLER,**

L'angelo custodia
(Angel case),

cotton,
Reggio Emilia 1996.

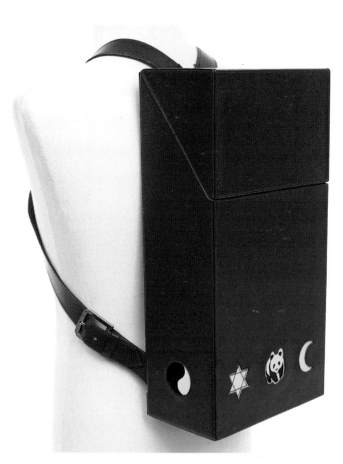

SERGIO CALATRONI,

Simboli
(Symbols),

leather,
La Fabbrica di Dedalo &
A. Guerriero Collection,
Milan 1994.

DAN FRIEDMAN,

La casa
(The house),

leather,
La Fabbrica di Dedalo &
A. Guerriero Collection,
Milan 1994.

GIUSEPPE DI SOMMA,

Incazzatissimo
(Really screwed),

plastic,
Florence 1996.

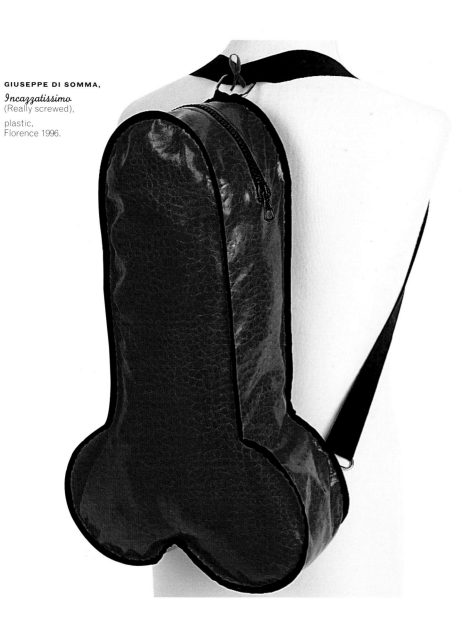

Index of Artists